YORK INDUSTRIES
THROUGH TIME
Paul Chrystal &
Simon Crossley

AMBERLEY PUBLISHING

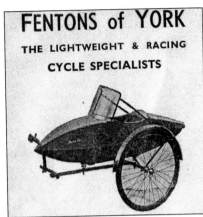

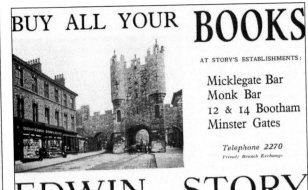

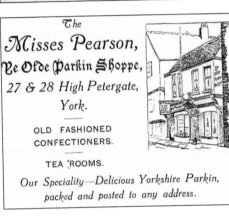

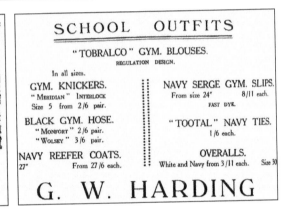

A selection of advertisements showing the diversity of York's businesses – ranging from Yorkshire Parkin to gym knickers, from the aptly named Story booksellers to early bicycles and sidecars.

To Phil and Helen

First published 2012
Amberley Publishing
The Hill, Stroud
Gloucestershire, GL5 4EP

www.amberley-books.com

Copyright © Paul Chrystal & Simon Crossley, 2012

The right of Paul Chrystal & Simon Crossley to be identified as the Authors of this work has been asserted in accordance with the Copyrights, Designs and Patents Act 1988.

ISBN 978 1 4456 0214 1

British Library Cataloguing in Publication Data.
A catalogue record for this book is available from the British Library.

Typeset in 9.5pt on 12pt Celeste.
Typesetting by Amberley Publishing.
Printed in the UK.

Introduction

The story of York's commercial heritage is somewhat less well known than many other aspects of the city's history. The city's business past is, nevertheless, extremely important, informing and defining as it does many other aspects of York's growth and development. This book sets out to depict and describe a number of York businesses and industries down the years, showing what has changed and what has remained largely the same.

Starting with the all-powerful medieval guilds, without whose consent trading in the city was virtually impossible, the book goes on to cover York's commercial arteries: shopping streets like Coney Street, Stonegate and Petergate, markets, and the Rivers Ouse and Foss. The Industrial Revolution largely passed York by: railways and confectionery are the two industries usually associated with the city; confectionery, of course, represented by Rowntree's, Terry's and Craven's. There were, however, others that made a vital contribution to the city's economy and which, in the case of Cooke, Troughton & Simms, were world leaders in the development and manufacture of telescopes and other precision instruments. Steam and chocolate apart, the city could also boast key employers in Redfearn's glassmakers and Bleasdale's pharmaceuticals company; it also has a long tradition in comb making, printing and publishing.

York is rightly famous for its shops, particularly its many independent retailers – a legacy, in part, of the city's popularity and relative affluence in the eighteenth century. Our tour of the city's many and varied shops provides a glimpse of how the businesses of the nineteenth and early twentieth centuries have changed to produce the shopping experience of today. Many of the older shops and businesses pictured and described, it must be said, would have been well out of reach of the average York resident: how many would have been able to afford Miss Bank's silks, muslins and crêpe de Chine or Joseph Wood's artificial eyes? Similarly, the clientele that patronised Betty's and Terry's cafés in St Helen's Square in the last century would all have been relatively well-healed. A number of the illustrations in this section were taken from Mate's 1906 *York Illustrated*.

One new and expanding difference between then and now though, and largely invisible from the street, is internet trade – an essential part of the sales mix for most of the new businesses pictured here through striking and dynamic websites.

Tourism is of course vital to the city's economy. York Minster and the Minster Library ensured that the city attracted ecclesiastical visitors; these were augmented by gentry from all over the north of England in the 1800s when the city won a reputation as a northern Bath, catered for by the Assembly Rooms and the New Walk along the Ouse. The assizes, public executions and horse-racing also brought in the crowds – in bigger numbers when the many trains started coming and going from York station. They continue to arrive today full of visitors coming for a day at the races, to visit the museums or to shop.

The book is obviously limited, to some degree, by the images available at the time of writing; nevertheless, despite these limitations, it provides the reader with a fascinating and nostalgia-evoking glimpse of York's industrial and commercial heritage. In so doing it gives resident and visitor alike a picture of the city, which is often overlooked, but which is nevertheless vital to the city's past, present and future.

Paul Chrystal

Acknowledgements

The following have been most generous in the provision of photographs and images for inclusion in the book: Melvyn Browne; Alex Hutchinson, Nestlé Heritage, York; Martin Dawson, York Observatory; Ian Drake, the Yorkshire Architectural and York Archaeological Society (YAYAS) for permission to use the Evelyn Collection photographs on pages 36 and 62; Stephen Lewis, *York Press*, for the pictures on pages 19 (old), 35 (new), 37 and 38 (both) and 66 (old). The photographs on pages 7 (both), 8 and 9 (old) courtesy of the Company of Merchant Adventurers of the City of York.

Paul Chrystal and Mark Sunderland are authors of the following titles in the *Through Time* series published in 2010: *Knaresborough; North York Moors; Tadcaster; Villages Around York; Richmond & Swaledale; Northallerton*.

Paul Chrystal and Simon Crossley are authors of the following titles in the series published or to be published in 2011: *Hartlepool; Vale of York; Harrogate; York: Places of Education; Redcar, Marske & Saltburn; In and Around York; Pocklington and Surrounding Villages; Barnard Castle and Teesdale; Rowntree and Terry – An Illustrated History; Cadbury and Fry – An Illustrated History*.

Other books by Paul Chrystal: *A Children's History of Harrogate & Knaresborough*, 2011; *An A-Z of Knaresborough History Revised Edn*, 2011; *Chocolate: The British Chocolate Industry*, 2011; *York and Its Confectionery Industry*, 2011; *The Rowntree Family in York*, 2012; *A-Z of York History*, 2012; *The Lifeboats of the North East*, 2012.

To see more of Simon Crossley's work please go to www.iconsoncanvas.com; to see Mark Sunderland's work visit www.marksunderland.com

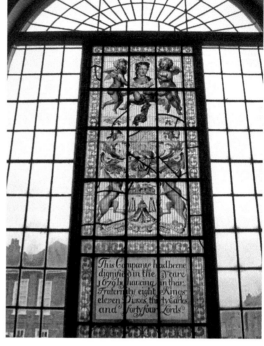

The Hall of the Company of Merchant Taylors
The Hall of the Company of Merchant Taylors in the City of York in Aldwark dates from 1446; these pictures of the interior show (on the left) one of two fine stained glass windows by Henry Gyles, this one dating from 1701 and, on the right, the banner of the guild of cordwainers (see also page 12).

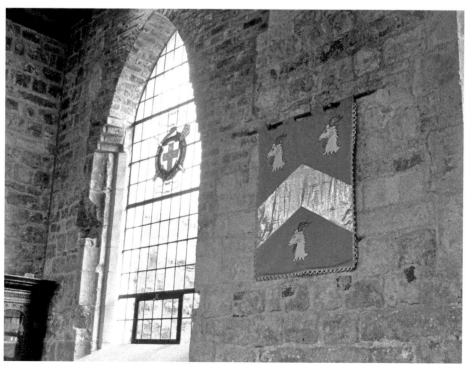

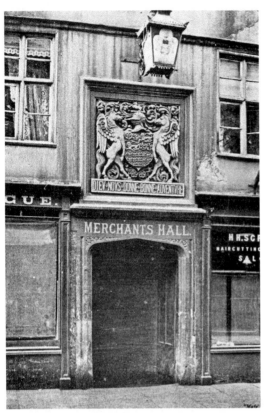

The Company of Merchant Adventurers of the City of York

For centuries, up until 1835 when the Municipal Corporations Act transferred control to local councils, the Guilds were all powerful and controlled York's trade and industry. To do business in the city it was necessary to be elected a Freeman of the City: a man or a woman had to be a Freeman before membership was allowed to the craft guilds. The Merchant Adventurers Guild goes back to 1357 when a number of prominent York men and women joined together to form a religious fraternity and to build the Merchant Adventurers' Hall. By 1430, most members were merchants of one kind or another; they then set up a trading association or guild using the Great Hall to conduct their business affairs and to meet socially, to look after the poor in the almshouses in the Undercroft and to worship in the Chapel. The pictures show the entrance in Fossgate in around 1930 and in 2011.

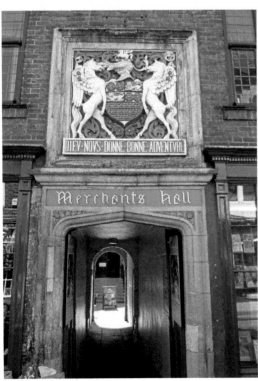

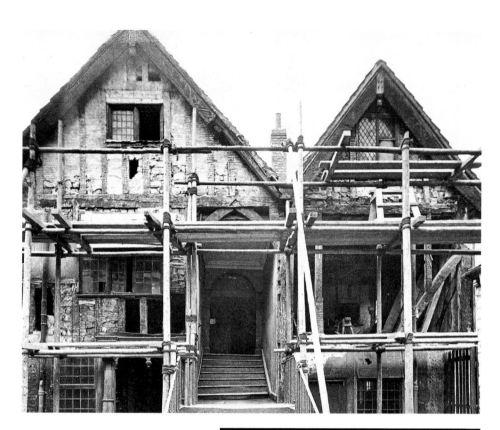

The Guild of Our Lord Jesus Christ and the Blessed Virgin Mary

A Merchant Adventurer was a merchant who risked his own money in pursuit of his trade or craft. Today the Guild is the Company of Merchant Adventurers of the City of York and the Hall is a museum, business, wedding and hospitality venue and home to unique collections of silver, furniture and paintings. These give a remarkable insight into the rich history of the hall and the people who have frequented it down the years. The archive contains documents dating from the early thirteenth century, predating the foundation of the Fraternity and Guild of Our Lord Jesus Christ and the Blessed Virgin Mary, the institution from which the present company is descended. The façade in the 1920s and as it is today are shown in the photographs.

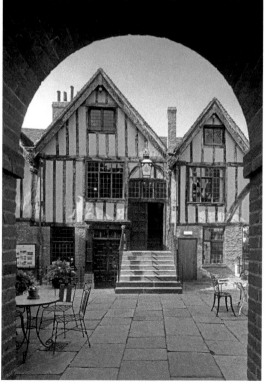

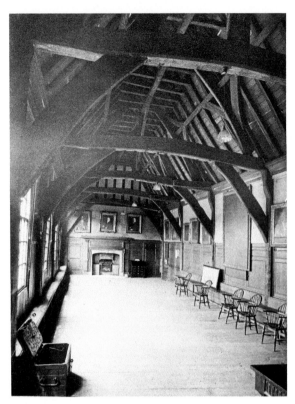

The Coat of Arms

The pictures show the Great Hall in the early 1900s and the resplendent coat of arms at the Fossgate entrance today; the French motto is 'God give us good (business) ventures'. It was made about 1850 by M. N. Hassey, who also carved the bust of Shakespeare at the York Theatre Royal and a statue of the Virgin Mary at the Bar Convent. The company used the coat of arms of the Merchant Adventurers of England until 1969 when they were granted their own.

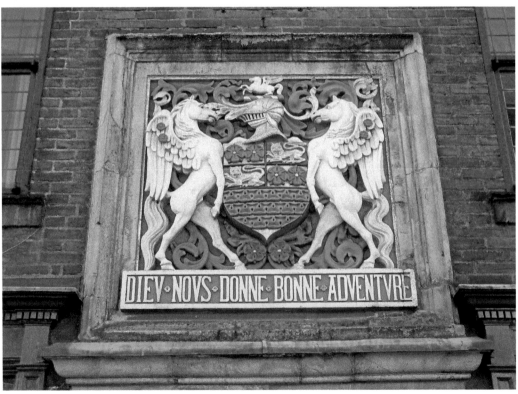

Piccadilly Façade

The lower part of the hall is built mainly of brick – the earliest surviving to be made in York since the Romans left. The company website tells us that 'It includes hundreds of original medieval charters, a cartulary containing copies of many of these charters, account rolls and books from the fourteenth century to the present day, rentals from the fifteenth century, maps and plans, building and repair accounts and records, records of admissions of members and apprentices, trade papers and minute books... there is a fine series of accounts beginning in 1432 and written on rolls of parchment. Many of the original deeds have their seals attached and the Company also possesses its original fifteenth century seal matrices'. The photographs show the Piccadilly façade and the grounds as venue for a wedding in July 2011.

The Company of Merchant Taylors in the City of York

One of seven guilds in York that date back to the thirteenth century and one of only three that have existed without break since medieval times. The Royal Charter of Incorporation of the Company of Merchant Taylors of the City of York was issued by King Charles II in 1662; however, the company can trace its origins back to the three medieval guilds of tailors, drapers and hosiers, the earliest references to which are the ordinances and register of members of 1387. The first reference to 'the land and hall of the fraternity of St John de Baptist' is in 1415, while the first mention of a York Taylor's almshouse comes in 1446. The building in Aldwark dates from 1446. In the early nineteenth century there were over forty drapers in York. The pictures are of the hall in the 1980s and in 2011; the interior is also shown on page 5 (upper) with one of two fine stained-glass windows by Henry Gyles, this one dating from 1701.

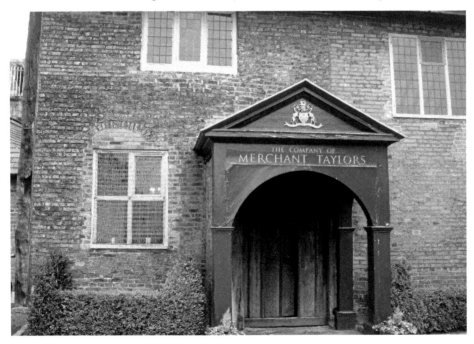

Bedern Hall and the Three Guilds

Since 1984, Bedern Hall (*see page 5*), the restored Common Hall of the Vicars Choral, has been home to three York Guilds: the Guild of Freemen of the City of York, Cordwainers and Builders. York's Freemens Rolls date from 1272: the Freemen were responsible for civil and criminal justice, controlled the guilds, supervised the training of apprentices, and the quality of goods. They kept the streets clean, kept the city walls in good order, maintained roads and bridges, built schools and provided troops for the monarch. The York guild's banners pictured here are: left to right: [top] glaziers, girdlers; [middle]: ropers, merchant adventurers, grocers; [bottom]: masons, clothworkers. As with the banners on page twelve these were originally published in *The Book of the York Pageant 1909*, published by Ben Johnson & Co., Micklegate, York, 1909. The banner of the Guild of Freemen can be seen on page 5 in the window along with the cordwainers' banner to its right.

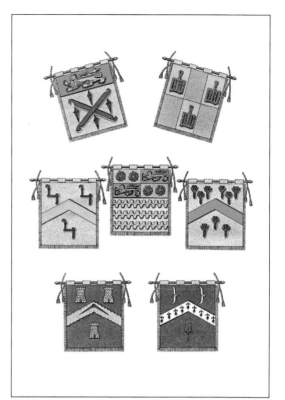

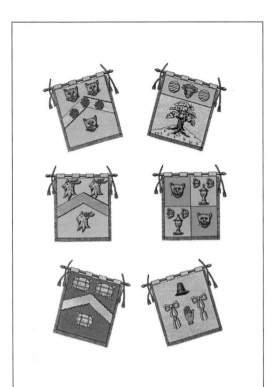

Cordwainers and Builders

Cordwainers worked in 'cordwan', a type of shoe leather named after the Spanish town of Cordoba, the principal medieval source of this leather. The 1272 Freemen's Rolls list over 200 Cordwainers here: the first entry is 'Thomas de Fulford, Cordwainer'. At the end of the sixteenth century, the guild's senior officials, known as 'Searchers', were empowered to inspect all leather and shoes coming into York, rejecting any they found to be of inferior quality. The banners here are, left to right [top]: weavers, tanners; [middle]: cordwainers, goldsmiths; [bottom]: dyers, feltmakers. The new picture shows Bedern chapel today.

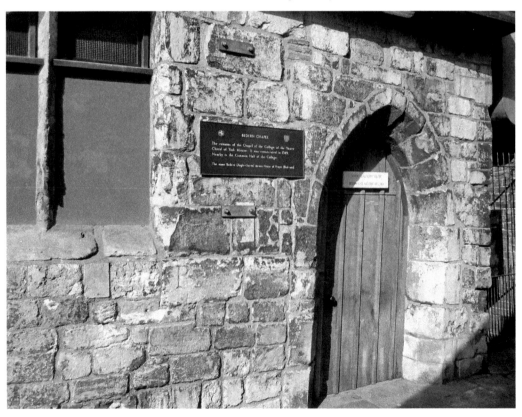

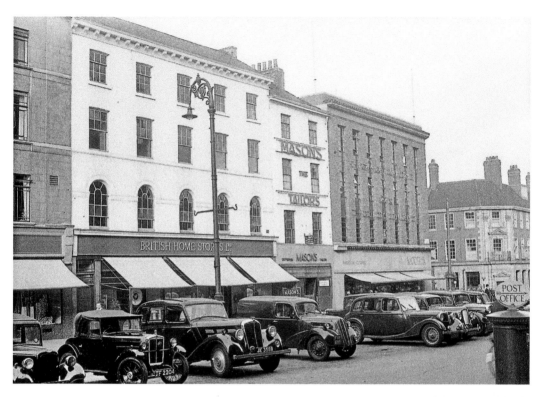

Parliament Street

Parliament Street in the late 1940s, and today with the famous fountain. Parliament Street dates back to 1836, when buildings were cleared to make way for a large market place; Thursday Market was then renamed St Sampson's Square. Parliament Street was the home of the market until 1955 when Newgate started to open up. The fountain dates from 1987 (*see also page 24*).

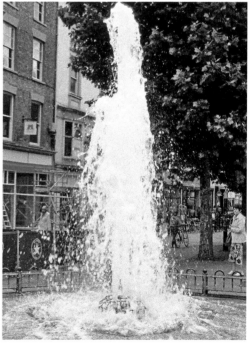

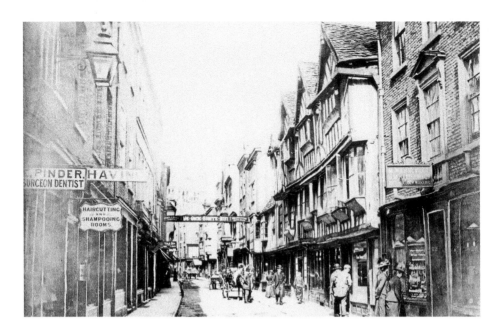

Stonegate

By common consent one of the finest streets in England, if not Europe, and York's first pedestrianised street laid down in 1971. The gallows sign of the Ye Olde Starre Inne was put up in 1792 by landlord Thomas Bulmer who had to pay the owner of the building over the street 5s rent per year. In 1886, the legend read Boddy's Star Inn; the Star was Charles I – popularly known as 'the Old Star'. Stonegate was once famous for its coffee shops (hence Coffee Yard) and its printers (hence the printer's devil on the corner of Coffee Yard). Roman paving survives under today's cobbles complete with the central gulley for the chariots' skid wheels.

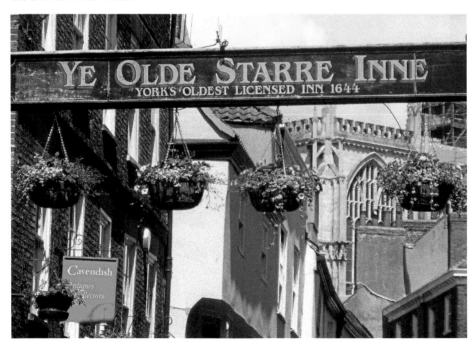

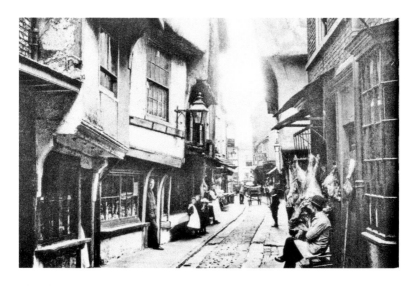

Shambles

The Domesday Book mentions Shambles; along with nearby Whipmawhopmagate it is one of the most famous streets in the world and certainly the most visited street in Europe. In 2010 it won Google Britain's Most Picturesque Street Award. Shambles was originally called High Mangergate, then Haymongergate, designating the hay that was here for the livestock to eat before slaughter; later it took the name Needlergate after the needles made here from the bones of slaughtered animals. Its present name (at first The Great Flesh Shambles) derives from the fleshammels – a shammel being the wooden board the butcher's used to display their meat on. Butcher's would throw meat that had gone off, offal, blood and guts into the runnel in the middle of the street to add to the mess from the chamber pot disposal that came from the overhanging jetties. A real shambles. The old image was first published in *York in 1837: A Souvenir of the 60th Year of Her Majesty's Reign* and shows the street around 1897.

Robertus Witheskirtes and Nich de Nunnewyk

In 1280, seventeen butcher's paid an annual shammel toll of seventy shillings between them; in 1872, twenty-five out of the thirty-nine shops here were butcher's out of a total of eighty-eight in the whole of York; one butcher's can be seen here on the left. There were also four pubs: the Globe (closed 1936); the Eagle and Child (closed 1925); the Neptune (closed 1903) and the Shoulder of Mutton (closed 1898). The street was purposefully narrow to keep the sun off the meat. The Butcher's Guild is another of the three surviving medieval guilds (*see page 10*); the Rolls give two butcher's (or carnifices) for 1272: Robertus Witheskirtes and Nich de Nunnewyk. You can still see the butchers' hooks on some of the shop fronts today (*see pages 15 and 17*).

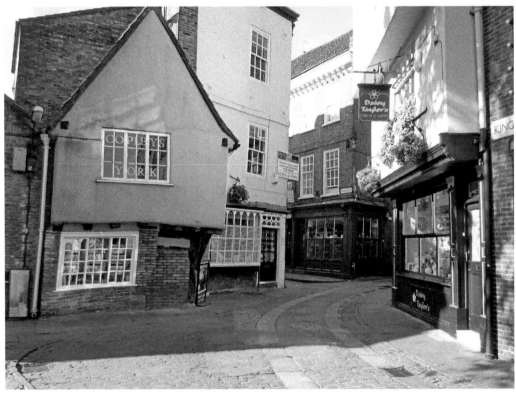

The Butcher's Guild

The Butcher's Guild was one of only four in York to have its own hall; the others were Haberdashers, Merchant Taylors and Merchant Adventurers – all the others used St Anthony's Hall. The Butcher's Hall was called Gell Garth in Little Shambles, built in the fourteenth century; this is a rare picture of it on the right. They fought the city's schamel toll in 1377 and were prominent in the Peasants' Revolt in 1381. Today members meet in Jacobs Well in Trinity Lane.

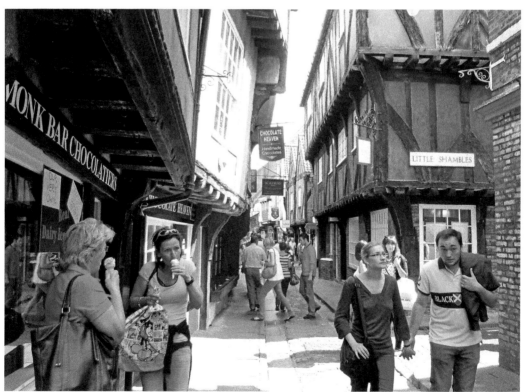

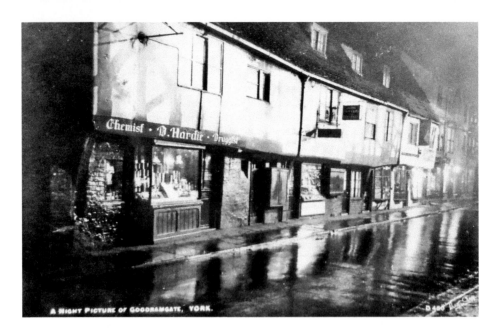

Goodramgate

Goodramgate is named after Guthrum, a Danish chieftain from around 878. The Grade I listed Lady Row cottages (pictured here at night and in early morning sunlight) date from 1316 – the oldest surviving jettied cottages in Britain. Originally nine or ten houses, the one at the southern end was demolished in 1766 to make way for a gateway to the thirteenth–fifteenth-century Holy Trinity church. They each comprised one room, ten by fifteen feet, on each floor. Rents paid for chantries to the blessed Virgin Mary in nearby churches. Two pubs occupied the cottages at various times: the Hawk's Crest from 1796–1819 and the Noah's Ark around 1878.

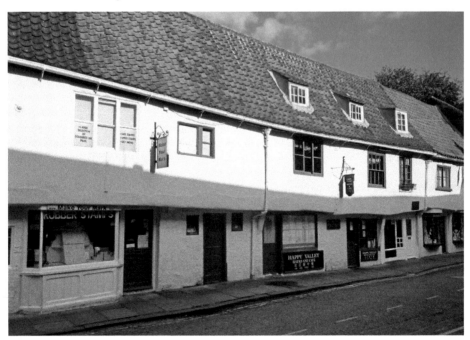

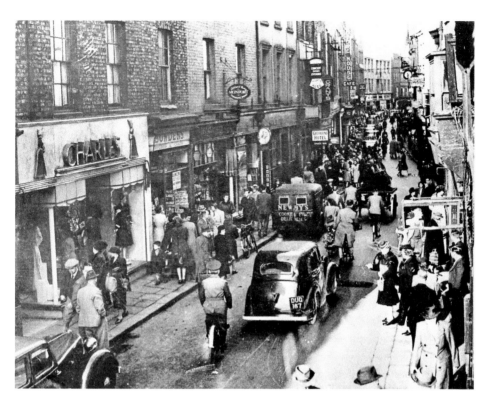

Coney Street

Coney Street has long been an important thoroughfare and shopping street. In 1213 it was called Cuningstreta, from the Viking *konungra* – king – and *straet* – street. Famous businesses have included Leak & Thorp's built on the site of the fourteenth-century Old George Inn, which was demolished in 1869 (*see page 81*). Archibald Ramsden's piano and organ shop moved there from St Sampson's Square. The Black Boy Chocolate Kabin, later sold to Maynard's, was next door to Leak & Thorp; the *York Press* printed there as did the *Yorkshire Herald*. The older picture shows Coney Street in the 1940s from Spurriergate; the newer picture shows some interesting faces looking down on Coney Street.

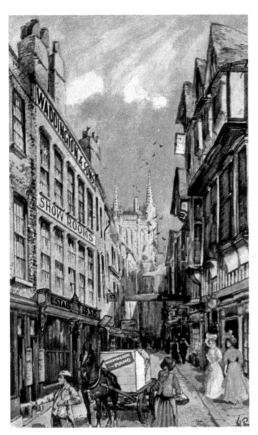
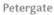

Petergate

Another fine shopping street. Sir Thomas
Herbert lived here – Charles I's secretary,
with him at his execution. Misses Pearsons
Ye Olde Parkin Shoppe was at 27–28 'old
fashioned confectioners' and specialists in
'Yorkshire Parkin – packed and posted to any
address' (*see page 4*). Guy Fawkes was born
hereabouts, baptised at St Michael-le-Belfry
and a pupil at St Peter's School.

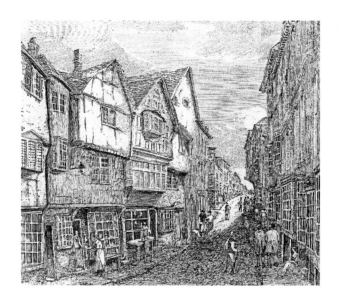

Ousegate

We have seen how butcher's were concentrated around Shambles (and Thursday Market, from 1836 St Sampson's Square); other crafts or trades had similar concentrations. Ousegate and Castlegate were famous for their lorimers (makers of bits and bridles) and spurriers; cutlers were to be found near St Michael-le-Belfry; pinners at St Crux; girdlers at Girdlergate (Church Street), tanners near North Street (hence Tanner's Moat and Tanner Row); fishmongers on the Foss and Ouse Bridges; parchment and leather workers and prostitutes at Harlot Hill (St Maurice's Road today), and prostitutes also in Grope (Grape) Lane. The modern picture shows how our history and heritage lives on in the shape of the local history book display in Waterstone's in High Ousegate. The old image is the street in Regency times.

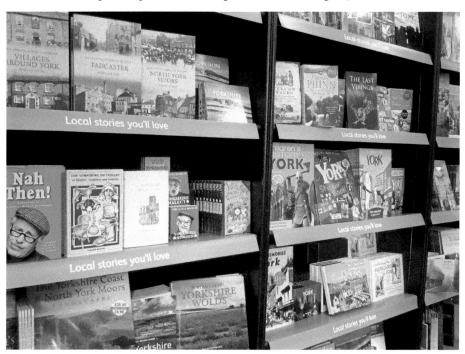

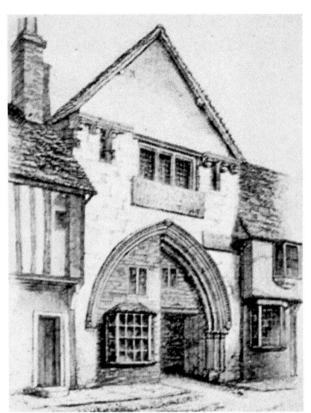

Micklegate

Previous names were Myglegate (1161) and Myklegate (1180). This depicts the 1809 Benedictine Priory, which was demolished to make way for Priory Street; the pub on the site, the Priory, is the only evidence of its existence. Joseph Hansom (1842–1900), the architect and inventor of the cab that bears his name, was born nearby; the Hansom Cab pub is in Market Street. Hansom, a victim of depression, shot himself in his office on 27 May 1900. There are stocks in Holy Trinity church further down the road and a memorial to Dr John Burton, historian and prototype for Dr Slop in Sterne's *Life and Opinions of Tristram Shandy, Gentleman.* The old image was first published in *York in 1837: A Souvenir of the 60th Year of Her Majesty's Reign* and shows the Priory around 1897.

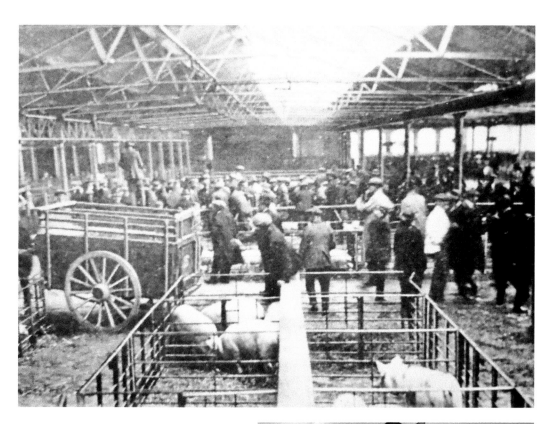

The Cattle Market

The opening of the cattle market in Fawcett Street led to the reopening of Fishergate Bar to enable cattle to be driven through; it also saw the end of the time-honoured practice of keeping livestock behind the butchers' shops and slaughtered on site, as happened in Shambles for many years.

A cattle market existed here from the fifteenth century; the market building comprised 44 pens, which could hold 616 fat cattle, some less fat ones and 6,750 sheep. The market served the city for nearly 150 years when it moved to Murton having closed in 1971; it was demolished in 1976. The Fishergate Postern shown here (previously the Talkan Tower) – *posternam iuxta Skarletpit* – dates from 1502 and is York's only surviving example. The Barbican Centre, refurbished in 2011, was built on part of the cattle market site in the late 1970s.

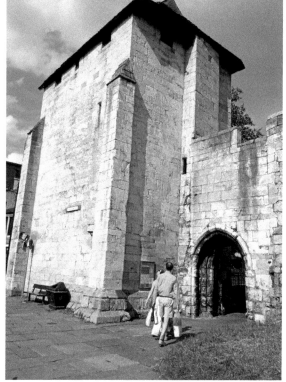

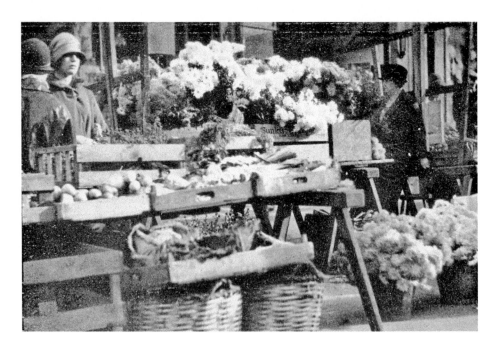

Parliament Street Market

York's main market was held here until 1955 when the move to Newgate began, taking nine years to complete. Parliament Street is still the venue though for frequent weekend, local produce and continental markets. Originally, the market extended from Pavement to St Sampson's Square, five rows of stalls deep. The modern, florid picture was taken outside Wards the florist in Clifford Street. The older photograph first appeared in *York Historical-Pictorial* published in 1928 by Hood & Co. of Middlesbrough.

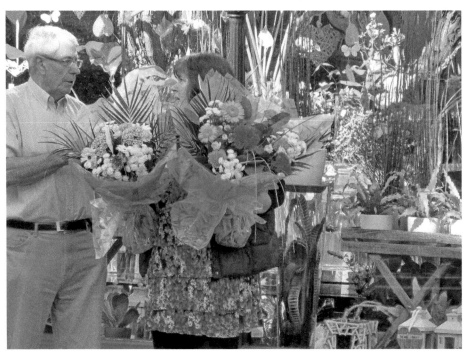

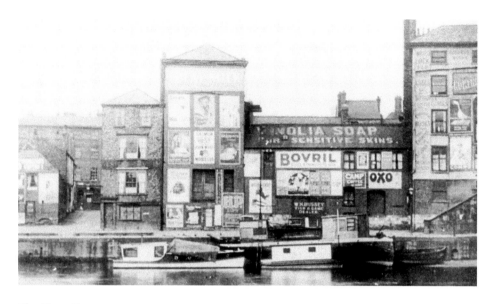

The River Ouse

The River Ouse was crucial to York from earliest times, right through the Roman and Viking occupations and in the Middle Ages, making York an important port. Evidence of Irish and German boats dates from around 1125. The photograph shows Queen's Staith in 1925 and the plethora of advertising it attracted. Today, the commercial river traffic has largely been replaced by pleasure boats and sailing club canoes; the river banks, particularly the New Walk, provide pleasant riverside walks and a cycle route to Selby. There is a ship's figurehead in Stonegate where this, and the timbers from which many of the city's buildings were built, indicate York's history as a port.

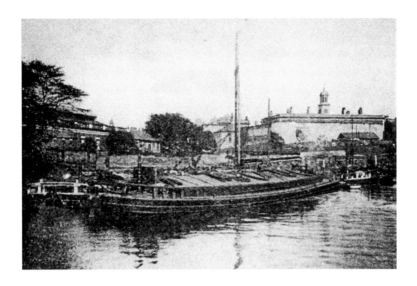

The River Foss

In 1069, William the Conqueror dammed the River Foss near to its confluence with the Ouse to create a moat around the castle; this caused the river to flood upstream to form a large lake known as the King's Pool or the King's Fish Pond. King's Pool was an integral feature of the city's inner defences during the Middle Ages as the marsh was virtually impassable and explains why there is no city wall between Layerthorpe Postern and the Red Tower. Roman jetties, wharves and warehouses have been excavated on the river banks, indicating that water-borne transport and trade was important from Roman times. Foss Bridge (*here*), at the end of Walmgate dates from 1811 and replaces a 1403 stone bridge and a wooden one before that. The fish shambles was held here as was the Saturday pig market (the tethering rings still exist) and the goose fair. Foss Basin is in the old photograph with the Eye of York in the background. Industry on the Foss can be seen on page 27 in the shape of Leetham's flour mills in 1912 and 2011; the mills employed 600 workers at their height.

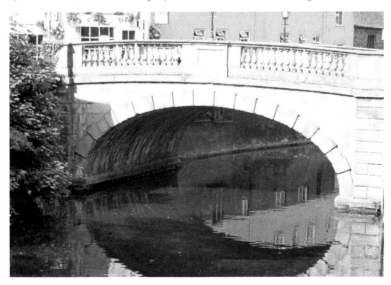

Chapter Three: Industry

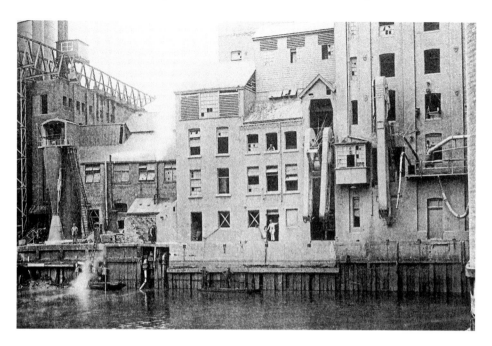

Leetham's

Leetham's flour mills have been symbolic of York industry since 1985, as the home of Spiller's flour and Rowntree's confectionary from 1937, an important user of the Foss. The nine-storey water tower survives today with its battlements and turrets – an impressive landmark on the city's skyline.

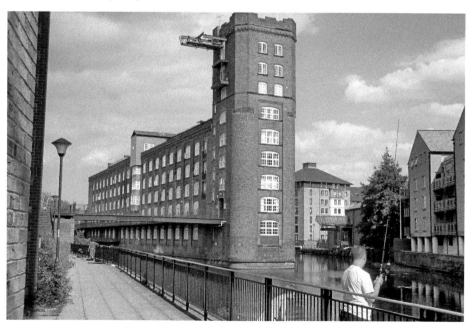

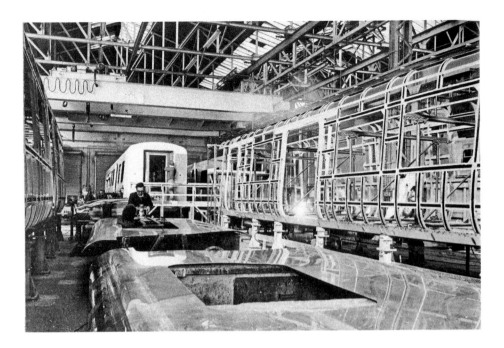

The Railways are Coming

The River Ouse was the main transport route before the railways came. *White's 1840 Directory* was highly optimistic about the benefits of railways in the future: 'The formation of railways to open a better communication with the West of Yorkshire and the North and South of England, are in progress and with these improved modes of transit for goods, it is to be hoped that the trade of York will improve.' People employed in York on the railways spiralled from 41 in 1841 to 513 in 1851; many were involved in engine repair and building at Queen Street where there was a 1,200-strong workforce by 1855. The older photographs on pages 28-29 were originally published in Ian Allen's *This is York Major Railway Centre*. This shows Class 313 units being built at York in 1976.

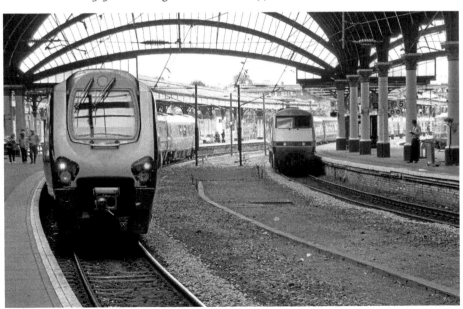

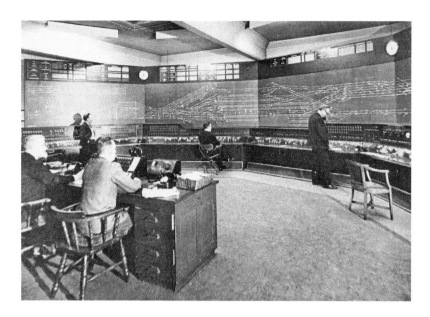

'Mak all t'railways cum t'York'

The next development was carriage and wagon construction – all of which moved to a 45-acre site at Holgate. The railways were York's first large-scale industry and its biggest employer. By 1900 there were 5,500 railway workers in the city, nearly half of whom were skilled. The Railway King, George Hudson, was prominent in York's development as a major railway city; his advice to George Stephenson was to make it a hub: *'Mak all t'railways cum t'York'.* The older photograph is of the control room in the 1951 signalbox at York station. The new photograph shows what was the headquarters of the old North Eastern railway, opened in 1906, through one of the arches built into the city walls; later it was HQ for British Rail Eastern Division and today is the Cedar Court Hotel & Spa.

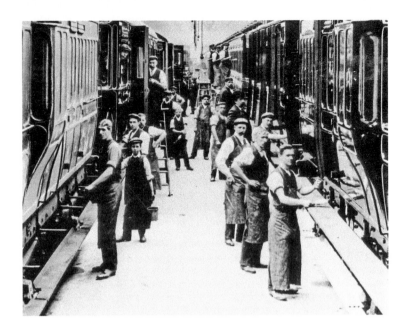

York: Railway Capital of the North

The first train left York for South Milford in 1839. The first London service was in 1840 via Derby or Birmingham and took about 10 hours. The railway replaced the five or so per day stage coach service to London York, which started in 1703 (carrying 24,000 passengers per year, a cosy 6 per coach, and taking 4–6 days depending on the weather) with 13 trains carrying 341,000 passengers. By 1888, there were 294 trains arriving at the station daily lending a massive boost to York's tourist industry. The emerging confectionery industry also benefitted enormously. The old photograph is of the varnishing shop at Holgate. The 8ft 10in diameter railway wheels in the new picture are the largest locomotive wheels in existence; they were cast at Bristol in 1873 to drive 4-2-4 Tender Loco No. 40, an express passenger train on the Bristol & Exeter Railway. The wheels have been outside the National Railway Museum since 1975.

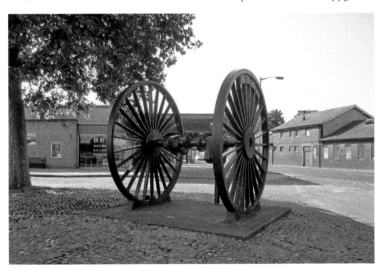

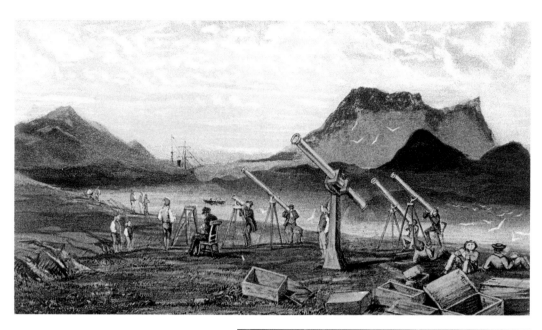

Cooke, Troughton & Simms – Optical Instrument Manufacturers

Thomas Cooke came to York in 1829 and made his first telescope using the base of a whisky glass for a lens and a tin for the tube. In 1837 he opened his first instrument-making shop at 50 Stonegate with a loan of £100 from his wife's uncle. Cooke quickly gained a reputation for high quality and was soon making microscopes, opera glasses, spectacles, electrical machines, barometers, thermometers, globes, sundials and mathematical instruments as well as telescopes. By 1844 he had expanded and moved to 12 Coney Street. The old picture is *Commencement of the Total Eclipse of 28 July 1851 at Blue Island Norway* from a watercolour by Charles Piazzi Smyth, the astronomer in charge; the telescopes included those made by Cooke, Troughton & Simms. The new photograph is of the clock-driven Equatorial Telescope in the observatory made by Thomas Cooke in 1850, through which you can see the stars and planets at night and safely observe the sun during the day.

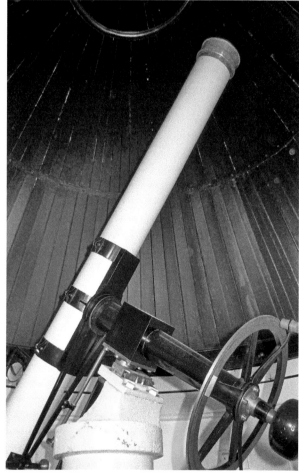

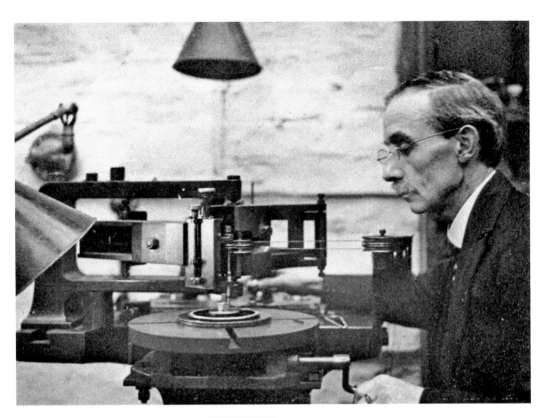

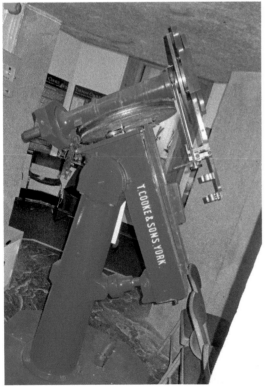

Cooke, Troughton & Simms and Vickers

In 1856, Cooke moved into the Buckingham Works, built on the site of the home of the second Duke of Buckingham at Bishophill – one of Britain's first purpose-built telescope factories. He built a telescope for Prince Albert in 1860 and one for a Gateshead millionaire; the telescope tube was thirty-two feet long and the whole instrument weighed nine tons – the biggest telescope in the world at the time. In 1893, H. D. Taylor, Optical Manager, designed the Cooke Photographic Lens, which became the basic design for most camera lenses thereafter. In 1915 control of Cooke's was acquired by Vickers Ltd who had had an eye on Cooke's military products. Troughton & Simms was established in 1922; in 1939 the Haxby Road site was built. Of the 3,300 people employed by the firm, 1,400 were women. The old photograph shows a C. T. & S. worker machine engraving and was originally published in *York Historical-Pictorial* published in 1928 by Hood & Co. of Middlesbrough.

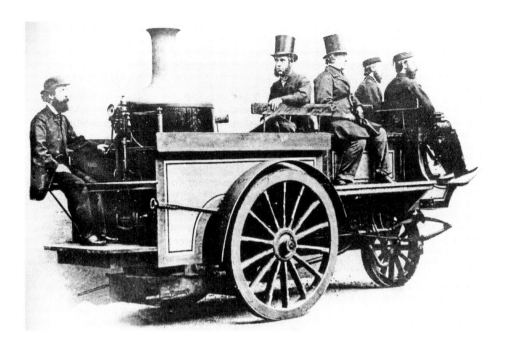

Steam Cars and the Law

In 1866, Thomas Cooke branched out into three-wheeled steam cars, which reached the dizzy speed of 15 mph; however, they were outlawed by the Road Act, which prohibited vehicles that travelled in excess of 4 mph. In those days a man with a red flag had to walk in front of any vehicle not pulled by a horse. Cooke fitted his steam engine into a boat and travelled on the Ouse, free of red flags. He died in 1868. Many of the instruments made by the company are now held in the University of York, The newer photograph shows the new National Science Centre at the University today.

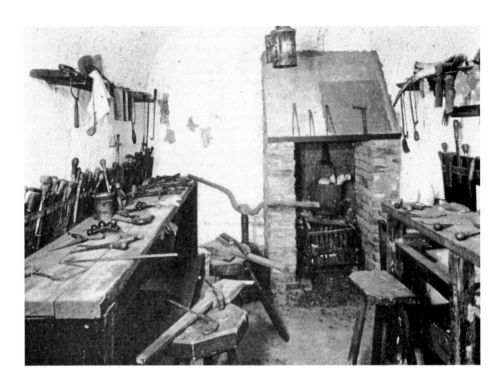

Hornbreaking and Comb Making

Comb making became a recognised craft in 1635 when the Livery Company of Combmakers received its charter. Comb and horn breaking flourished around Hornpot Lane off Petergate (now Tonge's Court) – near to the slaughterhouses in the Shambles. By 1784 there were sixty-five freemen, journeymen and apprentices engaged in the trade. Combmakers worked in ivory and tortoiseshell as well as in horn; books and manuscripts were covered with horn and the crockery of poor people was often made from horn. There is still a horn window to be seen in Barley Hall, as shown here. One of the more successful comb companies was Joseph Rougier, a maker of drinking horns, combs and lanterns from 1823 until 1931. Rougier was descended from a Huguenot family of wigmakers and hairdressers and gave his name to the street near his Tanner Row works. The older photograph shows typical comb-making tools and equipment.

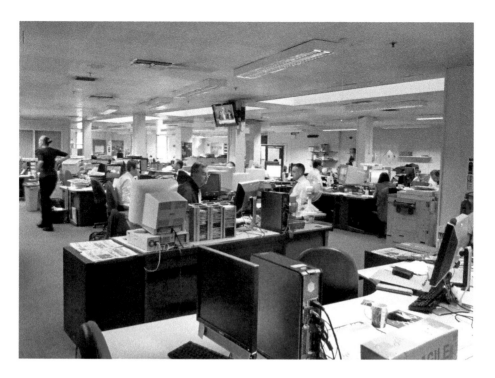

Printing and Publishing

Printing came to England in 1477 with William Caxton and is first recorded in York in 1497 when Fridericus Freez is noted as 'Book Bynder' and 'Stationer' and later as a 'Buke Printer'. Thomas Gent (1724–1778) was another famous York printer and a prolific publisher of chap books. The Quaker William Alexander set up a bookselling business in Castlegate in 1811, expanding into printing in 1814. This business was eventually taken over by William Sessions in 1865, and survived until 2009. The pictures show 281 years of change in the printing and publishing industry in York – the offices of *The Press* are in the newer picture and the caption to the older picture states 'Interior of Gent's Printing Office. York, 1730.'

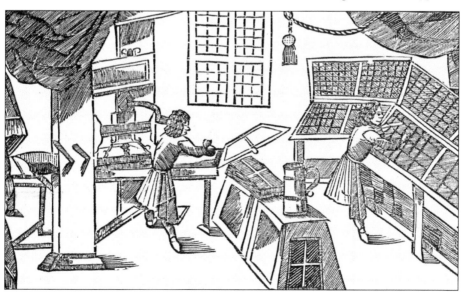

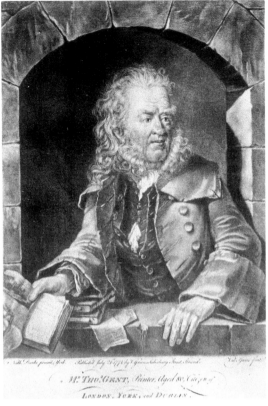

Mr. Tho. GENT, *Printer, Aged 80, Ætat, etc.*

LONDON, YORK, and DUBLIN.

Dr Dryasdust and the 'Printer's Devil'

Alexander refused to publish novels, considering them far too ephemeral. His self-censorship was to cost him dearly, if this story is to be believed. Walter Scott, while researching *Ivanhoe,* came to York and visited Alexander's bookshop where he suggested Alexander might publish his book. Alexander declined, saying 'I esteem your friendship but I fear thy books are too worldly for me to print'. He paid for his rebuff, though, as the bookseller is thought to be the 'Dr Dryasdust' to whom Scott dedicated the book. The 'Printer's Devil' carving in Stonegate at the corner of Coffee Yard has been there since the 1880s and signifies the importance of printing and publishing industries in the area. The picture of Thomas Gent is a mezzotinto engraving by Valentine Green after Nathan Drake.

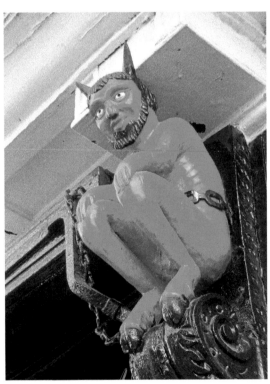

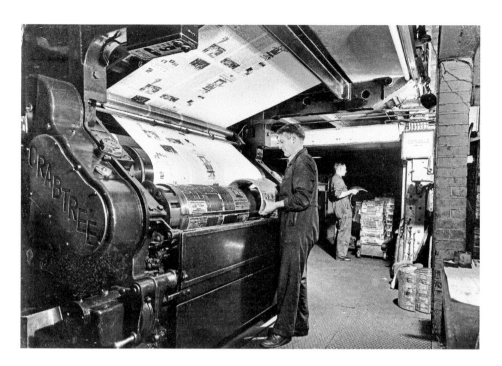

The York Mercury and Thomas Gent

The York Mercury, York's earliest newspaper, printed by Grace White, the owner of her late husband's printing house in Coffee Yard, was first published on 23 February 1719. Charles Bourne took over the printing house in 1721 and in 1724 Thomas Gent, author of *History of York*, acquired the business. Gent's first issue, for 16–23 November 1724, appeared under the new title of the *Original York Journal*, or *Weekly Courant*. By 1728, it was *The Original Mercury, York Journal,* or *Weekly Courant* and was published until 1739. The pictures show *The Evening Press* coming off the presses in the 1940s and the Coney Street offices in 1989 before the move to Walmgate.

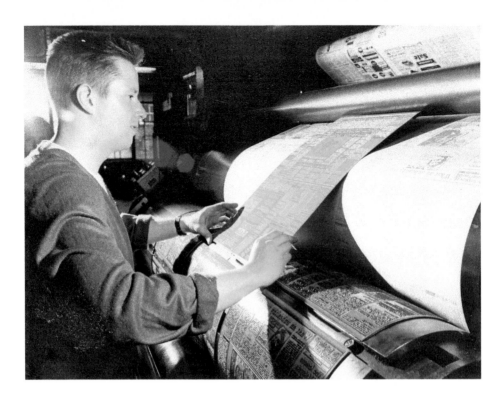

The Press

Titled the *Yorkshire Evening Press* since its first publication in October 1882 until the late 1990s, the paper changed from to tabloid format on 6 September 2004 and shortly afterwards dropped 'York' from its title and moved to morning publication on 24 April 2006, when the title changed to *The Press* to reflect this. More old technology in Coney Steet and new equipment being installed in Walmgate.

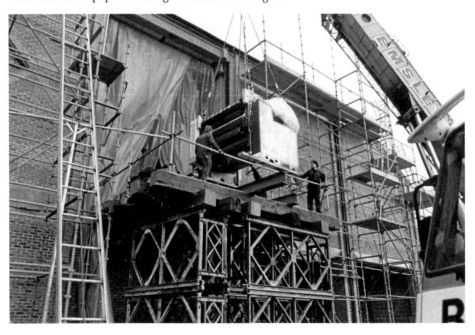

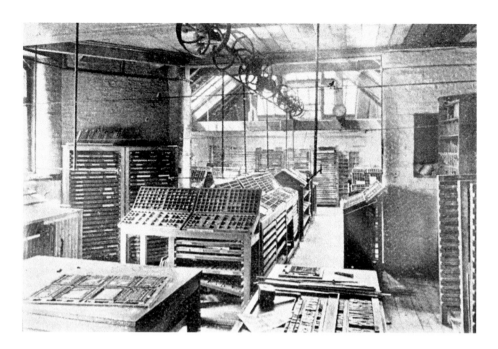

F. R. Delittle, Fine Art Printers, Lithographers, Bookbinders, Paper Rulers, Publishers etc
Printers and bookbinders at 6 Railway Street, also publishers of the *Yorkshire Chronicle and Delittle's York Advertiser*, which had a circulation of 12,000 copies in 1897. They also produced the *City Chronicle* and *Sheffield Advertiser*; staff numbered 60 in 1900. Books published included *Eboracum, The Yorkshire Road Book* and *Delittle's Picturesque York* as well as *York in 1837*, in which this old photograph of the hot metal composing department was first published. The modern picture shows printing in York today in the shape of Quack's in Grape Lane, publishers of such local books as *The Nature of the World: The Yorkshire Philosophical Society 1822–2000* and *War Comes to York*, both by David Rubenstein, *The Almshouses of York* by Carol Smith and David Potter's *The Bells and Bellringers of York Minster*.

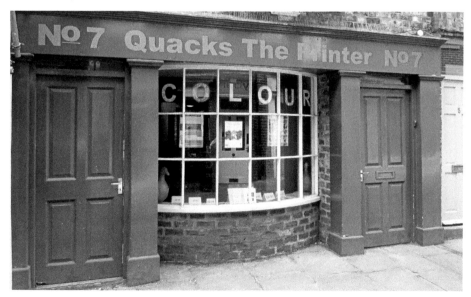

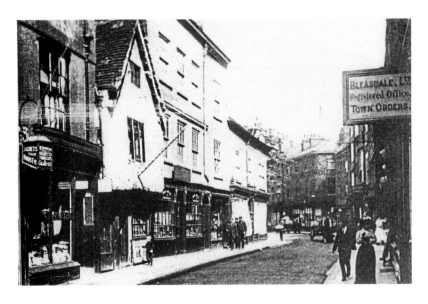

Bleasdale, Pharmaceutical Manufacturers

1780 saw the establishment of John Dale's Bleasdale Ltd, manufacturing and wholesale chemists behind Colliergate. A visitor to the firm in the 1930s leaves us with the following description: 'after traversing a dark corridor, found ourselves confronted by a locked door – the entrance to the Poison Rooms. For the first time in my life I saw samples of raw opium – and very disinteresting they looked.' He would also have seen barrels of black beer, cod liver oil and machinery for grinding liquorice, trimming rhubarb and grinding poppies. Other pharmaceutical and chemical manufacturers included Wright & Prest in Pavement, Edward Wallis & Son in Bedern and Thomas Bishop at North Street Postern. There was also Raimes & Company from 1818 in Micklegate and Henry Richardson & Company, fertilizer makers founded in 1824 at Skeldergate Postern in Clementhorpe.

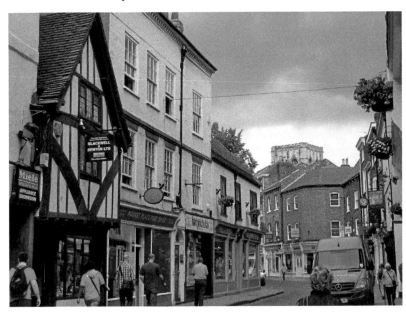

The Glassworks

The first glassworks was opened in 1794 by Hampston & Prince near Fishergate making flint glass and medicinal phials. The York Flint Glass Company was set up in 1835 and by 1851 was a larger employer than either Terry or Craven. In 1930, it was incorporated as National Glass Works (York) Ltd, which became Redfearn National Glass Company in 1967; demolished in 1988 and replaced by the Novotel. Sand for the works came via the Foss Islands Branch Line Depot (*see inset*). The line (operational from 1879 to 1988) also served the electricity power station and cattle market. The map shows the glassworks towards the top left with the cattle market on its right.

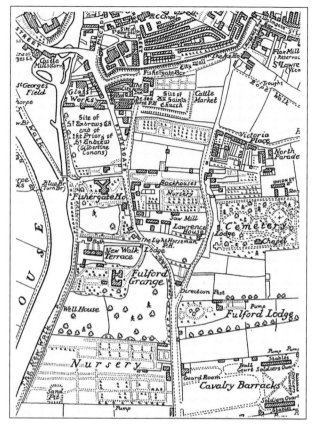

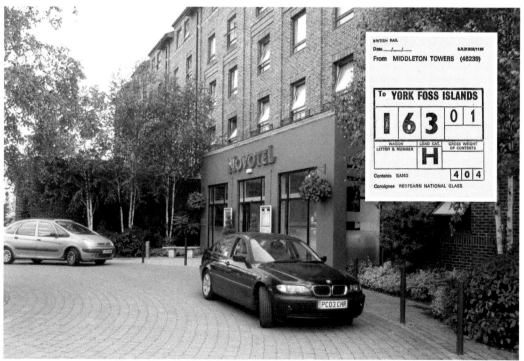

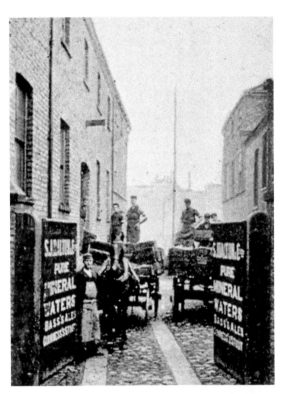

S. J. Dalton & Company

Mineral water manufactory, beer and stout bottling vaults in Skeldergate. Dalton previously worked at Savory & Moore, London – chemists to the Her Majesty the Queen. D. Moore was another mineral water manufacturer in Backhouse Street, the Groves, established in 1816 and specialising in horehound beer. Their dandelion stout and hop bitters won gold medals at the York Exhibition in 1896. Forster & Taylors in Dale Street off Nunnery Lane were also aerated water manufacturers. The modern picture is of Skeldergate Bridge today – it used to lift, but no longer.

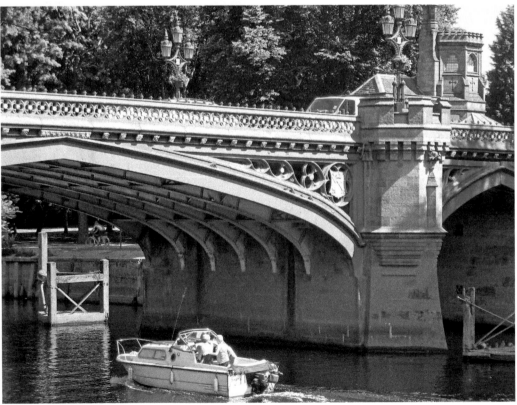

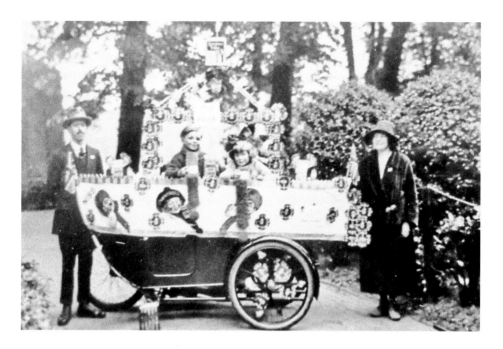

Rowntree's and Mary Tuke

The Rowntree story begins with Mary Tuke, descended from a famous Quaker family, whose grandfather was jailed for his non-conformism in the 1660s. In 1725, age 30, Mary established a grocery business first in Walmgate, then Castlegate and, after a number of legal wrangles with York Merchant Adventurers Company, finally won the right to trade as a grocer in 1732. The old picture shows a mobile Rowntree's stall in Rowntree Park. Some of the original Haxby Road buildings have been sold off. This shows part of the Cocoa Works up for sale in 2011 with the Joseph Rowntree Memorial Library in the foreground.

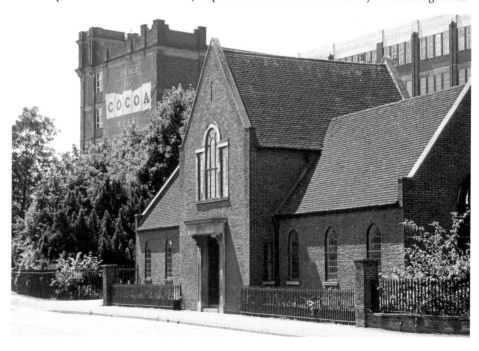

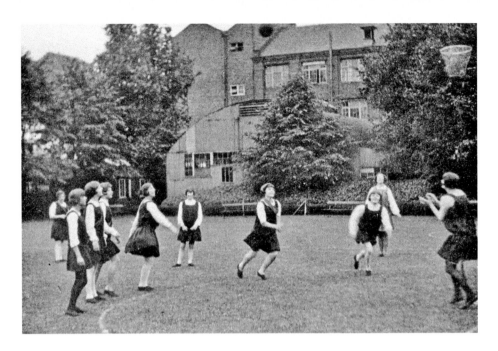

Rowntree's and Tanner's Moat

In July 1862, Henry Isaac Rowntree (who had served his apprenticeship both at the family shop in Pavement and at Tuke's) bought the Tukes' business. Henry relocated the firm to an old foundry at Tanner's Moat in 1864; in 1869 he was joined by his brother, Joseph Rowntree II, and the firm H. I. Rowntree & Co. was established. Joseph brought much-needed business acumen to the company and focused on the financial and sales side, leaving the manufacturing to Henry. The old picture shows a game of netball at Rowntree's in 1928 (originally published in *York: Historical-Pictorial*) with the Joseph Rowntree Theatre still going strong in the new photograph.

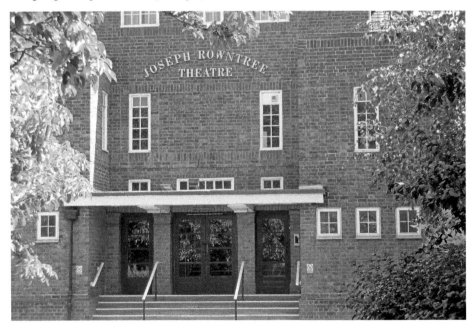

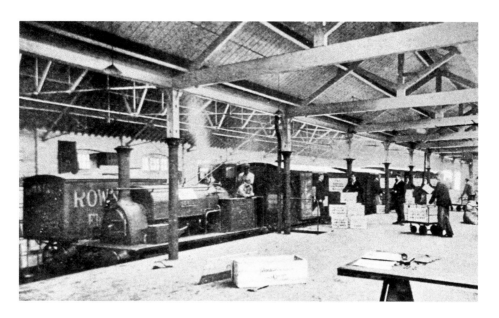

Joseph Rowntree's Vision

The success of fruit pastilles and fruit gums enabled Joseph to invest in new machinery in 1880, notably a Van Houten press for the production of cocoa essence – Rowntree's Elect, made from top quality cocoa. Joseph bought a 20-acre site on Haxby Road in 1890 with a view to building a more efficient and ergonomic factory, which would enable the firm to meet the growing demand for their products. He also established the Joseph Rowntree Trust and began the building of New Earswick at the turn of the century. The objective of the Trust in developing the idea of the new garden village was to provide the worker of even the lowest means a new type of house that was clean, sanitary and efficient. The new image is of the old Dining Block, which has been the Nuffield Hospital since 2004.

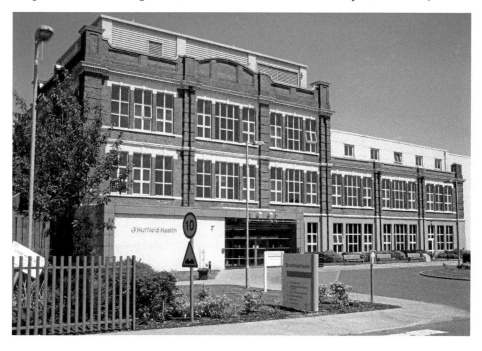

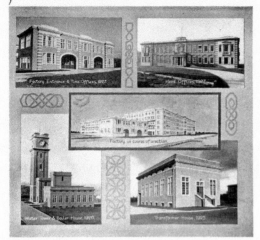

JOSEPH TERRY & SONS Ltd.

VIEWS of TERRY'S CHOCOLATE WORKS at BISHOPTHORPE ROAD

YORK, ENGLAND

MANUFACTURERS of
Chocolates, Boiled Sugars, Sugared
Almonds, Marzipan & Calves' Jelly

Est. 1767

THE SIGN OF
GOOD
CHOCOLATES

Terry's of York

On the other side of the city, Joseph Terry had been making cocoa and chocolate since 1886 and by the end of the 1920s had become the market leader in chocolate assortments. Originally they were based in St Helen's Square and manufactured boiled sweets, marmalade, marzipan, mushroom ketchup and calves' jelly. Conversation lozenges, precursors of *Love Hearts* (with such risqué slogans as *'Can you polka?'*, *'I want a wife', 'Do you love me?'* and *'How do you flirt?'),* were particularly popular. The older image is a 1928 advertisement; the new photograph is of Terry's 135-foot-high tower, clearly showing the famous clock.

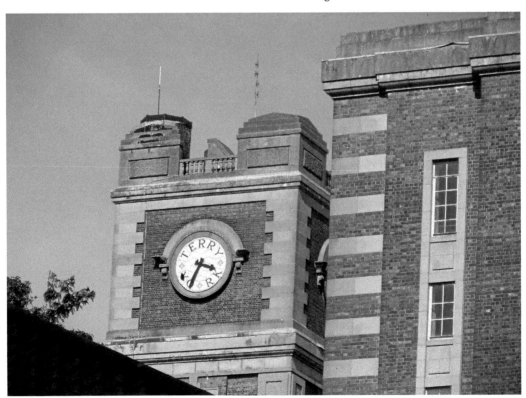

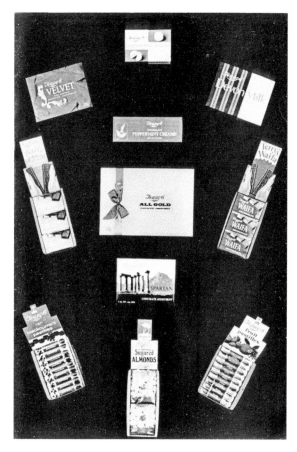

Terry's and Bishopthorpe Road

In 1864, the firm moved to
Clementhorpe on the River Ouse,
giving warehousing space and access to
the Humber estuary and the North Sea,
which, along with the new railways,
helped deliveries of sugar, cocoa and
coal. St Helen's Square was retained
and converted into a shop, ballroom
and restaurant (*see page 79*) and
Neapolitans were launched in 1899. In
1926, under the auspices of Frank and
Noel Terry the company moved again
to the purpose-built Chocolate Works
in Bishopthorpe Road, which still
stands today. The old pictures depict
some of Terry's famous brands.

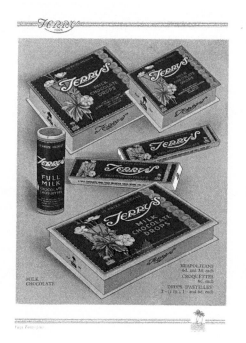

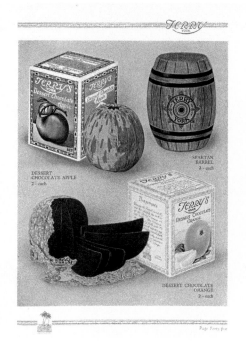

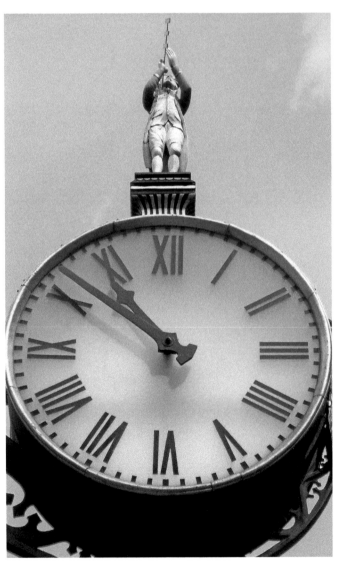

Craven's

The company originated in 1803 when Joseph Hick set up as a twenty-nine year old in York as Kilner & Hick, confectioners. Kilner left town, leaving Hick with the business, which he relocated next door to 47 Coney Street, what was then the Leopard Inn opposite St Martin's church. Mary Ann Hick was born in 1829 and in 1851 she married Thomas Craven; he bought a building in Pavement from William Dove and a further site at 10 Coppergate, both of which expanded his own confectionery business. Note the emphasis on health and hygiene in the 1920s advertisement. The new image is of St Martin's church complete with Little Admiral on top holding his cross staff (an early sextant).

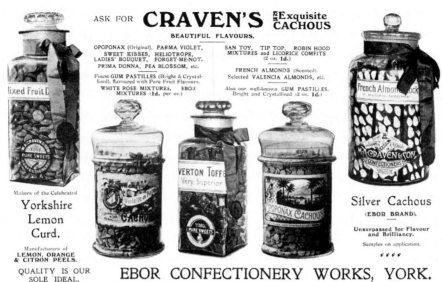

ASK FOR **CRAVEN'S** Exquisite CACHOUS

BEAUTIFUL FLAVOURS.

OPOPONAX (Original), PARMA VIOLET, SWEET KISSES, HELIOTROPE, LADIES' BOUQUET, FORGET-ME-NOT. PRIMA DONNA, PEA BLOSSOM, etc.

Finest GUM PASTILLES (Bright & Crystallized), flavoured with Pure Fruit Flavours. WHITE ROSE MIXTURES, EBOR MIXTURES (1d. per oz.)

SAN TOY, TIP TOP, ROBIN HOOD MIXTURES and LICORICE COMFITS (2 oz. 1d.)

FRENCH ALMONDS (Scented). Selected VALENCIA ALMONDS, etc.

Also our well-known GUM PASTILLES. Bright and Crystallized (2 oz. 1d.)

Makers of the Celebrated
Yorkshire Lemon Curd.

Manufacturers of
LEMON, ORANGE & CITRON PEELS.

QUALITY IS OUR SOLE IDEAL.

Silver Cachous (EBOR BRAND).

Unsurpassed for Flavour and Brilliancy.

Samples on application.

EBOR CONFECTIONERY WORKS, YORK.

Craven's and Tangerine Confectionery

In 1860, Joseph Hick died and his estate was divided up between his three children. In 1862, Mary Ann's husband died leaving her with three young children to raise and two businesses to run. Close to starvation she took up the challenge, amalgamated the businesses, changed the name of the company to M. A. Craven, and ran it for the next fifty-five years until 1916. In 1881, her son, Joseph William, joined the firm which became M. A. Craven & Son. Today the Craven brand is owned by Tangerine Confectionery, which manufactures sugar confectionery from their plant in Low Poppleton Lane. A range of confectionery is pictured in the advertisement. The new picture shows confectionery retailing in 2011 Low Petergate.

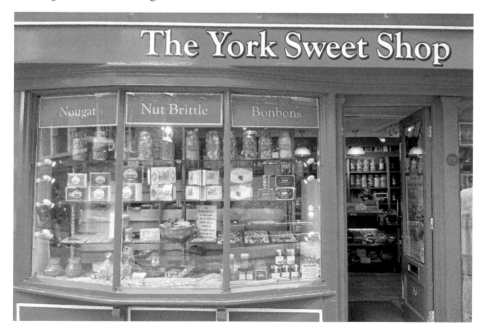

Fulford Biscuits

Fulford Biscuits in Coppergate and Heslington Road was run by Misses A. and F. Challenger who had brought their confectionery skills from Sheffield and Harrogate and bought the sole rights to produce the famous Fulford Biscuit from the estate of the late Mrs G. Leng. The Leng business had been set up in the 1820s and won prizes at the Leeds Exhibition in 1868 and the York Exhibition in 1866. Biscuits, breads, cakes and Fat Rascals on sale in Betty's St Helen's Square today.

Leak & Thorp
Leak & Thorp in Coney Street during the 1940s and the statuesque purple cyclist speeding down Stonegate in 2011.

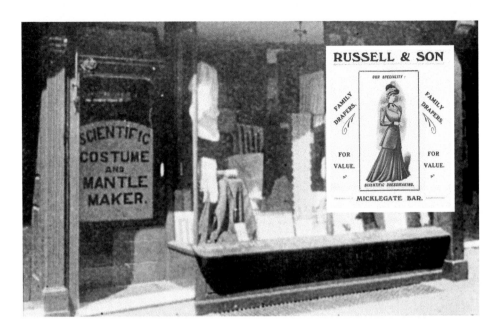

Russell & Son – Family Drapers

Not only were ladies' dresses the specialty of this 1851 established Micklegate Bar drapers but, as the advertisement shows, scientific dressmaking was their forte. John Grisdale in Coney Street was another ladies' tailor, although these were furriers too; silk mantles, voile and Eolienne Skirts were also for sale. The Scientific Dresscutting Association run by Miss Huggins at 35 Stonegate was run along similar lines: 'careful instruction is given to ladies in the art of dressmaking upon the newest and most scientific principles'. Patterns are 'guaranteed to fit'. John Hodgson in High Ousegate sold the very practical Fox's Patent Aquatic Hair Gambroons – a heavy duty material for collars and breeches. Modern dress in the Micklegate of 2011 is shown in the new picture.

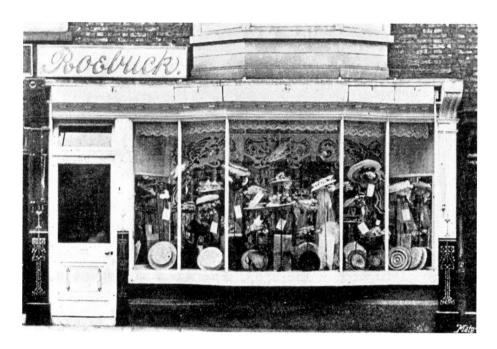

Madam Roebuck – High Class Milliner

'Modes for the Moment At Moderate prices' was the alliterative slogan for this high-class ladies' hat shop in Micklegate. Mrs Peacock ran a similar concern from her millinery rooms in Spurriergate; Joseph Cooke in Minster Gates was both retail milliner and wholesaler and he could offer seal skin, ostrich feathers and fluffy muffs, black and silver bear and blue fox. His straw hats and bonnets ranged from seven to thirty shillings. Hats featured prominently in the windows of Leak & Thorp (*page 51*); here they are again in Pavement today.

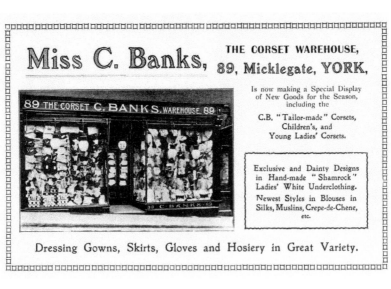

Miss C. Banks, THE CORSET WAREHOUSE, 89, Micklegate, YORK,

Is now making a Special Display of New Goods for the Season, including the

C.B. "Tailor-made" Corsets, Children's, and Young Ladies' Corsets.

Exclusive and Dainty Designs in Hand-made "Shamrock" Ladies' White Underclothing. Newest Styles in Blouses in Silks, Muslins, Crepe-de-Chene, etc.

Dressing Gowns, Skirts, Gloves and Hosiery in Great Variety.

Miss C. Banks – The Corset Warehouse

This Micklegate corset specialist offered tailor-made as well as off-the-peg corsets for children and young ladies. As with Russell & Son's the emphasis was on fine materials – silks, muslins and crêpe de Chine: 'The great desideratum of these goods is perfect fit combined with comfort'. Mrs Hopton in High Petergate bought her shapes from London and advertised 'a variety of fashionable stays for the present season, among which is the Grecian Bosom'. Also available were 'Patent Elastic, and Circular Steel Busks' and 'an assortment of Servants' Stays at very low prices'. Mrs Lyon, in Stonegate, sold 'Elastic French Steel Busks'. A fine example of a 2011 ladies' fashion shop is in Stonegate, pictured here with its (Dutch?) coat of arms; there is a listed hand-carved fireplace inside the shop.

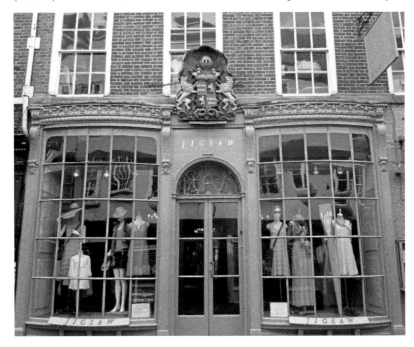

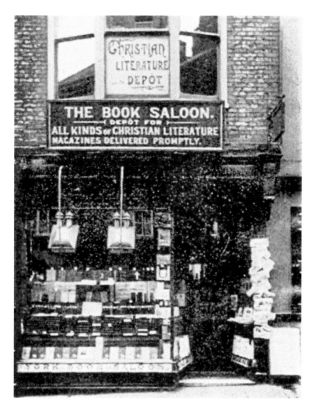

The Book Saloon

Occupied 6 Micklegate and stocked 'the largest and best selection in the North of England', according to *York in 1837*, which goes on to tell us that the bookshop 'meets the demand for healthy literature engendered by the rapid growth of education and educational facilities'. Waterstone's in High Ousegate is in the new picture with its 2011 window display for *York Through Time*.

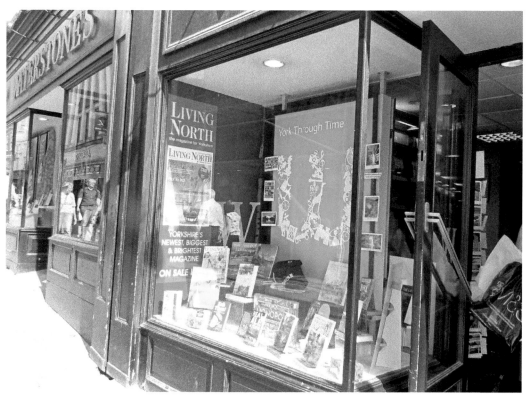

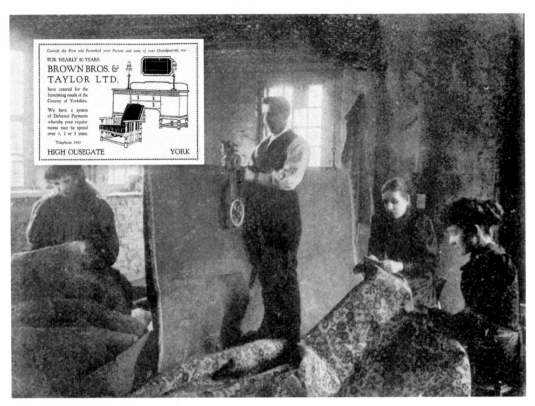

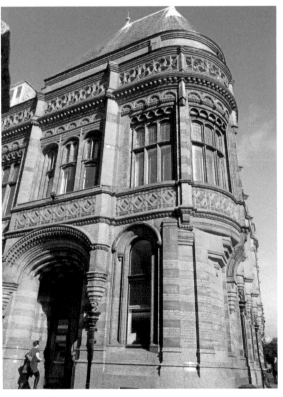

Brown Brothers

The complete house furnishers and decorators at 5–6 High Ousegate. The photograph shows the workshop with a Singer carpet sewing machine being used: 'does the work of six first class hands ... in this instance machinery has not deprived anyone of employment, but rather the perfection of seaming has increased trade and necessitated the employment of more finishers'. The new picture is the Grade II listed red brick Barclay's bank in the corner of High Ousegate and Parliament Street – built in 1901.

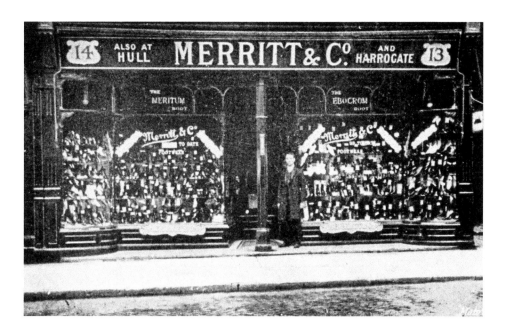

Merritt & Co., Boot Makers

When it came to shodding feet, Merritt's at 13–14 Low Ousegate, catered for everyone: 'abnormal and deformed feet receive special care' while provision is made for 'tired feet and enlarged joints'. Other York shoe and boot makers included MacLean's in Castlegate (strategically next door to the Robin Hood, now the Little John, coaching inn) and Bramley & Co. in Blake Street (strategically close to the Assembly Rooms). The new photograph shows a shoemakers in Church Lane since 1866.

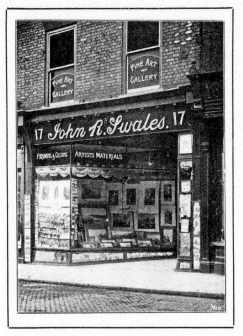

John R. Swales – Fine Art Gallery
'Choice reproductions of Choice Pictures' was the motto for this Low Ousegate gallery. Apart from paintings, the gallery also offered 'fine etchings of York Minster and quaint old street', postcards and view books. There are many modern art galleries and shops in York today; this one, Artestee Gallery & Café, is in Goodramgate and run by Estee Roberts.

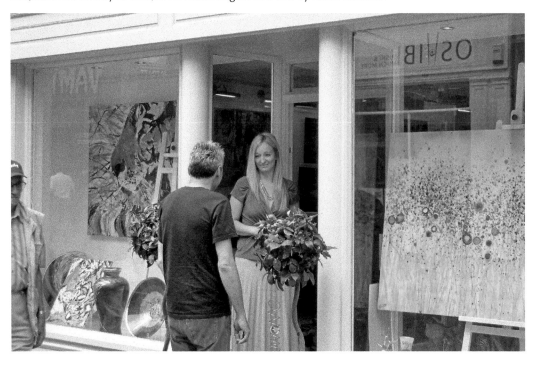

J. Lumb's, Tobacconists

At 13 Bridge Street this shop was notable for the striking life-sized wooden statue of Napoleon loitering at the door. It was one of three landed at Hull docks and bought for £50.00. Lumb's was also called 'The Smokeries and Stickeries' due to their specialisation in shilling walking sticks and all things for the smoker. The Indian above a shop in Low Petergate indicates the presence of a tobacconist below at some time in the past. Shop signs were popular in the eighteenth and nineteenth centuries when illiteracy was common and the average person could not read, for example, 'tobacconist's shop', and before the advent of house and shop numbering.

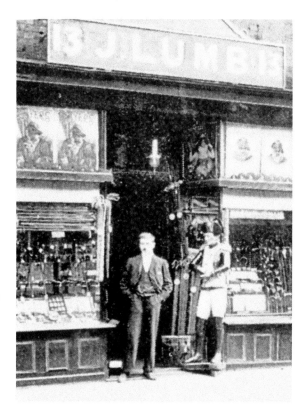

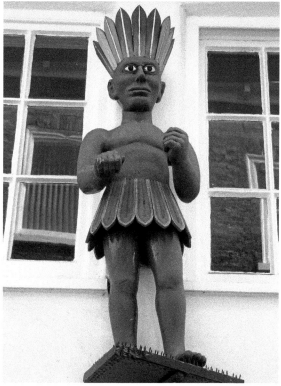

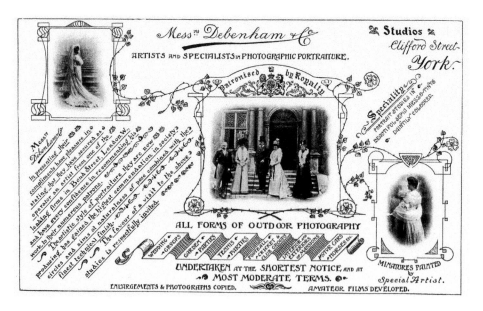

Messrs Debenham & Co. – Artists and Specialists in Photographic Portraiture
The complete 'artists and specialists in photographic portraiture' offering, from their Clifford Street studios, the services of a Bond Street artist, a clientele that includes Royalty, miniatures, developing amateur films, weddings and the interiors and exteriors of mansions. The newer image is of the York Institute, founded in 1827, an often-overlooked treasure of a building dating from 1883–85 in Clifford Street. York's library was here from 1892 before the move to Museum Street.

Wright's Ale & Porter Merchant
In addition to ales, Mr Wright sold mineral waters from his depot in Cumberland Street, conveniently close to the river. Devonshire Cider, Hop Bitters, and Cox's 'noted' non-alcoholic wines were specialties. High level work on the Ouse in 2011 at the end of Cumberland Street with the Grand Opera House on the right.

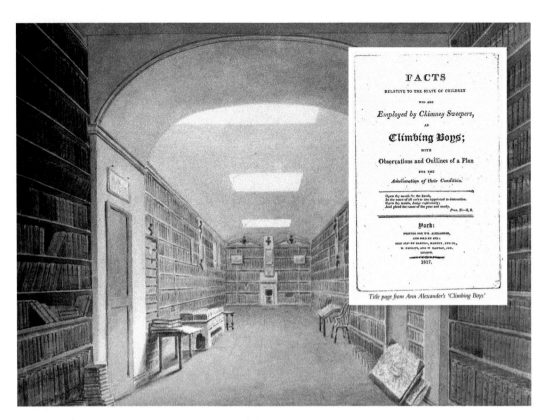

Title page from Ann Alexander's 'Climbing Boys'

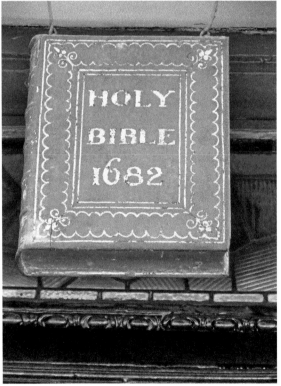

Todd's Book and Print Warehouse, Stonegate 1797

Todd's in Stonegate was very atmospheric with Roman busts watching over the 30,000 or so books. This is Henry Cave's *Todd's Book and Print Warehouse, Stonegate 1797*, which is part of the Evelyn Collection. As with all booksellers of the time, the shop was something of an apothecary too with a popular line in rat poison, Negus and lemonade and similar preparations and confections. William Alexander was a bookseller in Castlegate (*see page 35*). Ann Alexander was the author of this pamphlet campaigning against the exploitation of children and specifically against the employment of climbing boys in 1817; William was the publisher.

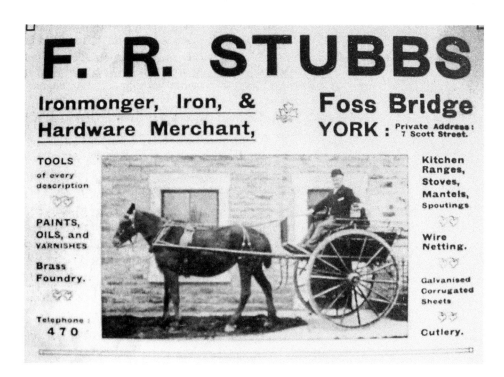

F. R. STUBBS

Ironmonger, Iron, & Hardware Merchant,

Foss Bridge YORK : Private Address: 7 Scott Street.

TOOLS of every description

PAINTS, OILS, and VARNISHES

Brass Foundry.

Telephone : 470

Kitchen Ranges, Stoves, Mantels, Spoutings

Wire Netting.

Galvanised Corrugated Sheets

Cutlery.

F. R. Stubbs, Ironmongers

The Stubbs sign on the wall of its grand old five-storey, thirty-seven-room building is as famous as the Bile Beans ghost advertisement in Lord Mayor's Walk. Established in 1904 by Francis Stubbs in Lady Peckitt's Yard the business (mainly suppliers to the trade) moved to its present Grade II listed building in 1915, Foss Bridge House, built in 1878. Stubb's slogan was 'Better Buy on the Bridge'. In 2001, it was bought by Loch Fyne Restaurants – Johnny Noble, owner of the Ardkinglas Estate and Andy Lane, fish farmer and biologist, started the business as an oyster bar on Loch Fyne, later branching out to selling oysters to restaurants and then opening their own restaurants.

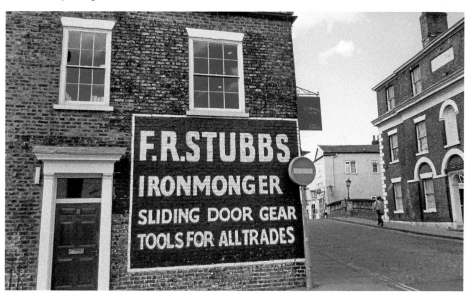

JOSEPH WOOD & Co., Ltd.

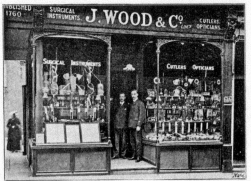

Spectacles,
Eye Glasses,
Eye Protectors,
Motor Goggles,
Opera and Field
Glasses,
Flasks, Barometers,
Pen, Pocket, and
Sportsmen's Knives,
Razors,
High-class Table
Cutlery.

Surgical Appliance
Makers,
Artificial Limbs,
Artificial Eyes,
Ladies' and
Gentlemen's Belts,
Elastic Hosiery, etc.
Trusses,
Private Fitting
Rooms,
Male and Female
Attendants.

National Telephone No. 0280. Registered Telegraphic Address—"Wood's, York."

**Surgical Instrument Makers,
Cutlers, and Opticians,** # Spurriergate, YORK.

Joseph Wood & Co. – Surgical Instrument Makers, Cutlers and Opticians

A fascinating shop in Spurriergate combining opticians, medical equipment suppliers and cutlers; the range of goods on offer extended from motor goggles, opera and field glasses, barometers, surgical appliances, artificial limbs and eyes and trusses. Private fitting rooms were available with male and female attendants. Competition came from Allison's in Church Street. The modern equivalent would probably be a surgical and medical supplier; the nearest I could get was the Haunted shop at 35 Stonegate with the skeleton in the window... 'When TV's *Most Haunted* came to investigate the crew ran out screaming.' This was originally York's oldest bookshop – the sign of the Bible (*see page 67*).

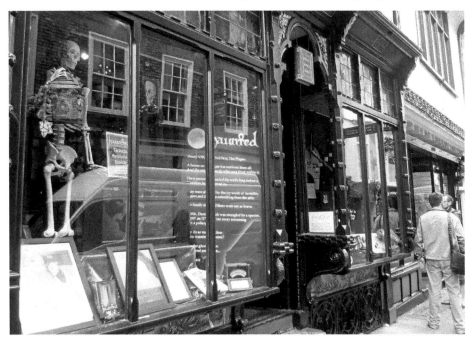

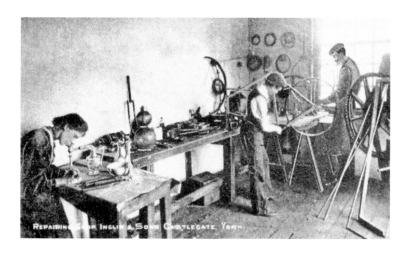

James B. Inglis & Sons – Watchmakers

Established in 1885, the showrooms were at 4 Coney Street (originally in Clifford Street) while the Crown Plating works were in Castlegate. Harness, carriage, motor-car and bicycle fittings were a specialty and their Kohinoor silver and plate polish provided the 'perfect polish' in liquid and powder form. Instead of waiting for the Corporation to supply his electricity Mr Inglis 'put down a small installation to light his premises' in the 1880s. His Sheffield suppliers of silver offered 5,000 lines 'all of which are practically in stock, as a wire will bring down any article by the first train'. The showroom for clocks was behind the shop 'where a wedding ring may be fitted without fear of interruption from other customers.' Pearce & Sons – Diamond Merchants – were next to the post office in Lendal. Edward Jackson in Coney Street specialised in pearls and 'a fashionable assortment of Mourning Rings' while near neighbours Robert Cattle and James Barber were famous for their silver tokens, which were issued and redeemable at their face value in lieu of cash. Mango now occupies 4 Coney Street.

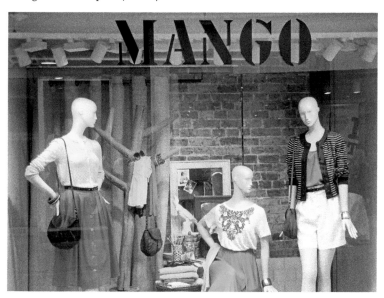

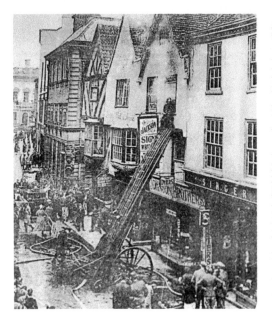

Leak & Thorp

The Coney Street department store offering – as do department stores today – a wide range of clothing, carpets and furniture. An interesting line was their portmanteaux, dress baskets, suit cases and luncheon baskets. John Mush in Monkgate and Dean Wolstenholme in Gillygate near the Bootham junction also specialised in carpets and curtains. Whitby C. Oliver was upholsterer, cabinet maker and undertaker in Micklegate, whose household goods for this life and the next complemented the flooring, curtains and blinds also available here. Other firms offering a similar service included John Taylor in Peter Lane selling 'improved upright mangles'. The old pictures show a 1933 fire at Johnson's Brothers, Coney Street gentleman's outfitters directly opposite Leak & Thorp and the Leak & Thorp fire in 1938. The new picture shows the site today (*see page 81*).

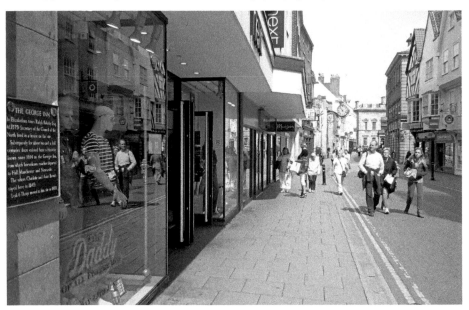

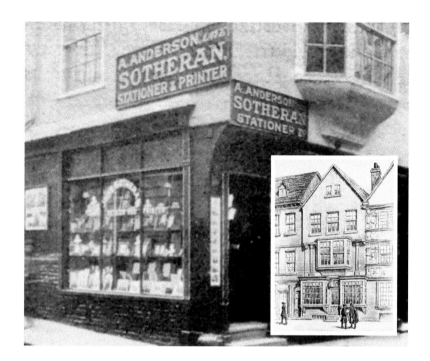

Arthur Andersons (Southeran's), Booksellers

In 1837, in Coney Street, the latest in a long line of York booksellers stretching back to Francis Hildyard's shop established 'at the sign of *The Bible*, Stonegate' in 1682 (*see inset*). This became John Todd and Henry Sotheran in 1763, until 1774 when Sotheran set up on his own next to St Helen's church, soon moving across the Square to where the Savings bank was. Thomas Wilson – Bookseller, Stationer, and Printer etc sold fancy goods, local guidebooks and postcards in Coney Street. Cash Stationery Store in Bridge Street offered 'a wide range of funeral cards'; John Wolstenholme sold books in Minster Gates, his building graced by his brother's fine statue of Minerva as in the new picture; and John Todd was in Stonegate next to Coffee Yard and the equally fine red Printer's Devil statue (*see page 62*).

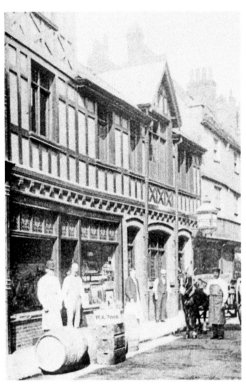

W.A. Todd, Wine & Spirits

Wine and spirit merchant in Davygate, next door to the London Hotel, to the right. Todd's specialty was 'Mountain Dew', apparently 'the oldest registered brand in the world.' The modern picture is of York's many colourful pubs; this is the Snickleway in Micklegate, a fifteenth-century galleried inn with open fires, once a brothel and Charles I's powder magazine during the Civil War. From 1896 to 1994 it was called the Angler's Arms. One of York's many haunted pubs.

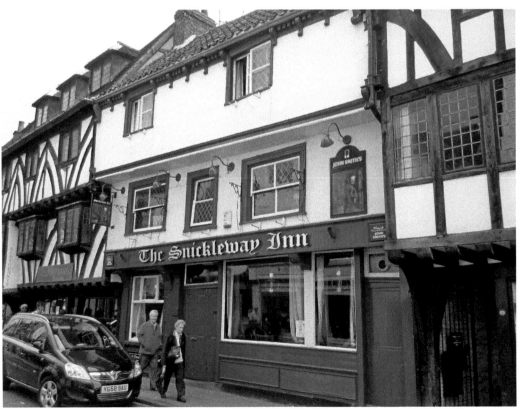

YORK WINE & SPIRIT COMPANY, Ltd.

CONTRACTORS TO HIS MAJESTY'S FORCES.

ESTABLISHED 1865.

TELEPHONE 339.

Ales in Cask or Bottle—

John J. Hunt's.
BASS & CO's.
WORTHINGTON'S.
ALLSOPP'S.

Lager Beer.

Guinness's Extra Stout

Devon and Hereford Cider.

Cigars and Cigarettes
Best Brands in stock.

Always in stock, leading Brands of
CHAMPAGNES,
BRANDIES,
WHISKIES, PORTS,
SHERRIES, etc., etc.

Specialities.

Liqueur Brandy Nips
18/- doz.
Champagne Nips 12/- doz.
Devon Cider Nips 2/- doz.
Dry Ginger Ale Nips
1/6 doz.

Mineral Waters.

Try our famous Lemonade,
Stone Ginger, Hop
Bitters, etc.
Soda in Syphons.

MINERAL WATER MANUFACTURERS.

—— ST. HELEN'S SQUARE, YORK ——
(Opposite TERRY'S).

York Wine & Spirit Company Ltd
An original off-licence, established in 1865 and situated opposite Terry's where Betty's now is. All manner of alcoholic beverages, cigarettes and mineral waters were on sale and ales came in bottles or casks. The company had a contract with His Majesty's Forces at the time.

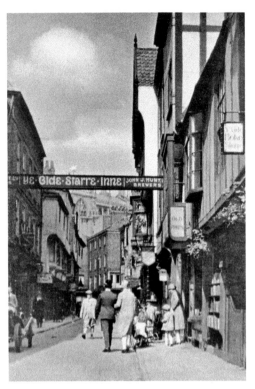

Thomas C. Godfrey, Bookseller

Thomas Godfrey was a phrenologist who made up his qualifications; he opened his first bookshop at 46½ Stonegate in 1895 selling second-hand books 'recently purchased from private libraries'. Godfrey 'became dissatisfied of the apathy of the citizens and disposed of the business' – a sentiment that could be echoed by many an independent bookseller today. An alternative report, though, attributes his failure to the selling of Oscar Wilde's *Portrait of Dorian Gray* after it had been recalled by the publishers, giving 'offence to some of the good people in York by his handling of a book which was regarded at the time as a most indecent publication'. Godfrey tried again in 1904 at 37 Goodramgate with the Eclectic Book Company, eventually moving back to 16 Stonegate as 'the Book Company'. In 1982 the business moved to 32 Stonegate and acquired a second shop on the campus at York University. The old picture shows Ye Olde Boke Shop in Stonegate; the new picture is the Yorkshire Terrier pub with its highly ornate façade.

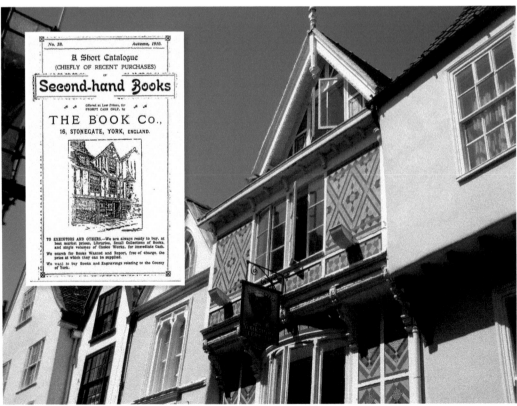

Palmer's – 'Chymist'

Palmers, in Stonegate on the corner of Coffee Yard and immortalised by Henry Cave's 1813 drawing. 'Cures for Green Sickness, Flatulence, Hypochondria and Turn of Life' were available and products typically included Whitehead's Celebrated Essence of Mustard, Ching's Patent Worm Lozenges and Ramsay's Medicated Spice Nuts for Destroying Worms. The elaborately carved wood and moulded plaster of Cave's drawing have mostly disappeared, although we do have a contemporary description: 'Bespread with a barbarous mixture of Grecian architectural ornament and others neither Gothic nor Grecian; while an embroidery of foliage and scroll-work appears to be crammed on every part susceptible of ornament.' The modern photograph shows that nearly all of this is now lost, compensated, in part, by the presence of the purple cyclist.

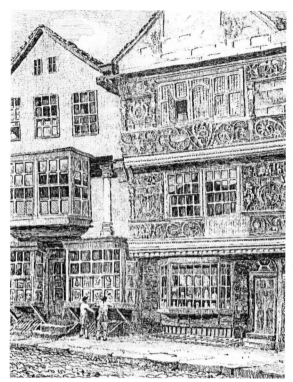

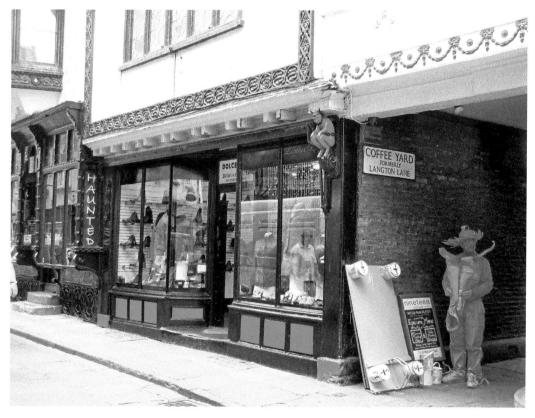

North Eastern Garages

Originally called Leather Brothers, this early motor car repair garage was the local Wolseley dealer and was open day and night and Sundays. 'Fast cars' were available for hire. In addition to the motor repair work, the company had a motor launch business at Lendal Bridge.

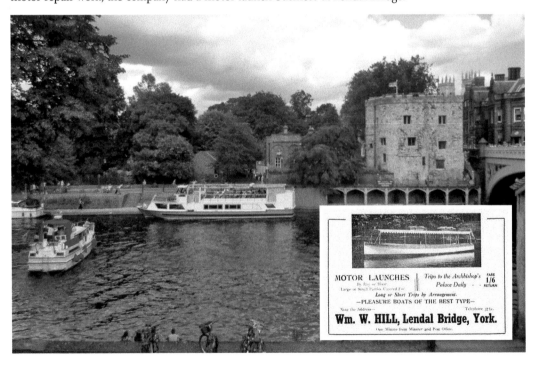

Waddington – Piano Specialists
The provision of musical instruments lives on in Lendal with Banks Musicroom, on the opposite side of the road from where Waddington's piano specialists traded. This advertisement appeared in the programme for *The Desert Song* by the York Amateur Operatic and Dramatic Society at the Theatre Royal in 1957.

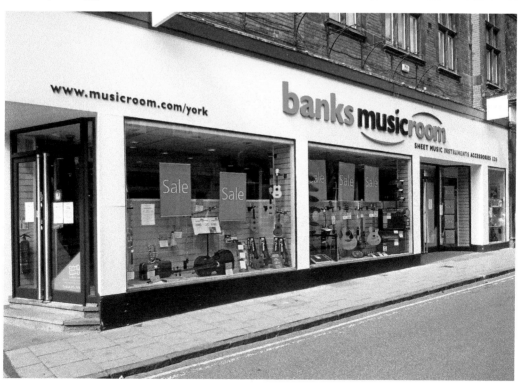

Barnitts

Barnitts have always been in Colliergate ever since the family firm was established over a century ago. Today it continues in its traditional business stocking everything anyone could possibly need for the home and garden. One difference is that today, Barnitts, like many others, has added an internet store to its credentials and sells a growing amount of stock on line.

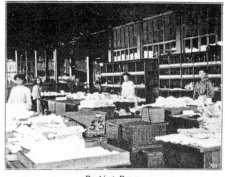
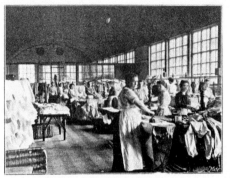
Yorkshire Laundries Ltd
Otherwise known as York Sanitary Steam Laundry, the Peaseholme Green Company had branches in six other Yorkshire towns and cities. The advertisement shows the electric ironing and the folding room. A suit cost from *2s 6d* while curtains were 'got up equal to new from *6d* per pair'. Competition in the form of the York County Hygienic Laundries Ltd ('High-class Launderers, Dyers and Cleaners and Carpet Beaters) operated from Foss Islands. The contemporary picture shows a peaceful River Foss at Peaseholme Green.

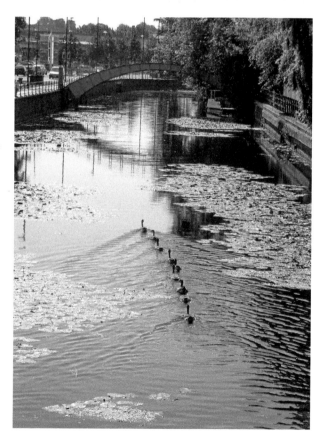

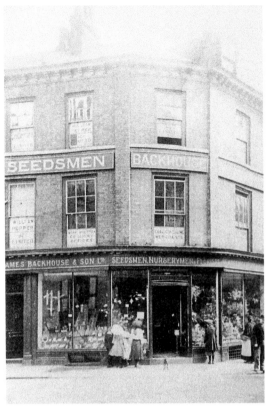

J. Backhouse & Son Ltd, Nurserymen

An original garden centre – one of three run by James Backhouse in Fishergate, with others in Acomb, Poppleton Road and Toft Green. James and his brother Thomas were celebrated nurserymen and their gardens were collectively called the Kew of the North. They were responsible for the cultivation of numerous rare plants, some of which James brought back from Australasia. Backhouse was producing catalogues since before 1821 when the second edition of their *Catalogue of fruit and forest trees, evergreen and deciduous shrubs, ornamental annual, biennial plants, also of culinary, officinal and agricultural plants* was issued. Today's photograph shows the florists at the Newgate market just off Parliament Street (*see page 24*).

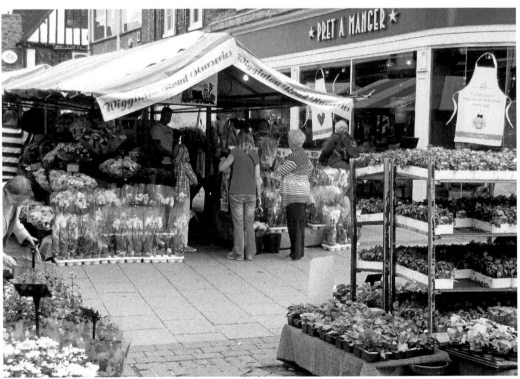

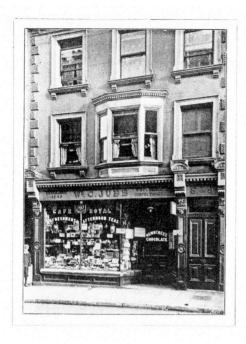

Café Royal,

8 & 9, Micklegate, YORK.

FIRST-CLASS REFRESHMENTS	at Popular Prices; Promptly and daintily served.	The Prettiest, most elegant and cosy Tea Rooms in the City.

Every accommodation for Visitors. Special Terms for Parties.	CYCLES, MOTORS, — Etc., STORED. —

Excellent, well-aired Beds.

✿ Wm. C. JUBB, ✿

Wholesale and Retail Confectioner.

Latest and Choicest British and
— Continental Productions in —
SWEETS, CHOCOLATES, BISCUITS, etc.

Very choice variety of FANCY PACKAGES, MECHANICAL TOYS laden with Chocolate, etc., suitable for presents.

Home-Boiled Hams and English Ox Tongues. Delicious Potted Meats, all prepared on the premises.

8 and 9, MICKLEGATE, YORK.

ESTABLISHED 1845.

The Coffee Yard

York has always been noted for its cafés, coffee and chocolate houses, hotels and public houses – as can be seen from the eighteenth-century Coffee Yard. The Café Royal leaves nothing to chance with teas, well-aired beds and sweets.

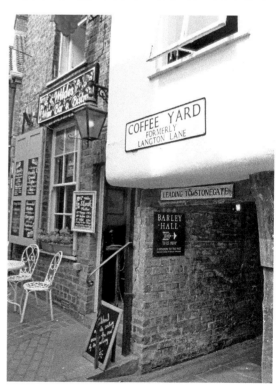

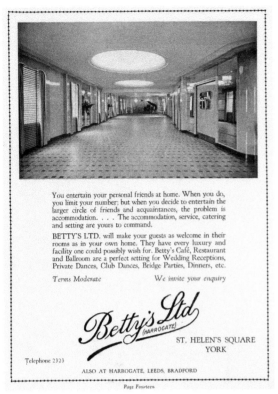

You entertain your personal friends at home. When you do, you limit your number; but when you decide to entertain the larger circle of friends and acquaintances, the problem is accommodation. . . . The accommodation, service, catering and setting are yours to command.

BETTY'S LTD. will make your guests as welcome in their rooms as in your own home. They have every luxury and facility one could possibly wish for. Betty's Café, Restaurant and Ballroom are a perfect setting for Wedding Receptions, Private Dances, Club Dances, Bridge Parties, Dinners, etc.

Terms Moderate *We invite your enquiry*

Betty's Ltd
(HARROGATE)

ST. HELEN'S SQUARE
YORK

Telephone 2323

ALSO AT HARROGATE, LEEDS, BRADFORD

Page Fourteen

Betty's

Betty's famous tearooms have occupied the old Harker's site since 1937. In 1936 the founder, Frederick Belmont, travelled on the maiden voyage of the *Queen Mary*. He was so impressed that he commissioned the ship's designers to turn what had been an old furniture shop into his most sophisticated tea rooms – and that's what you get in the art deco upstairs function room. The older photograph shows part of the upper floor; the newer one shows the teapot sign outside Little Betty's in Stonegate.

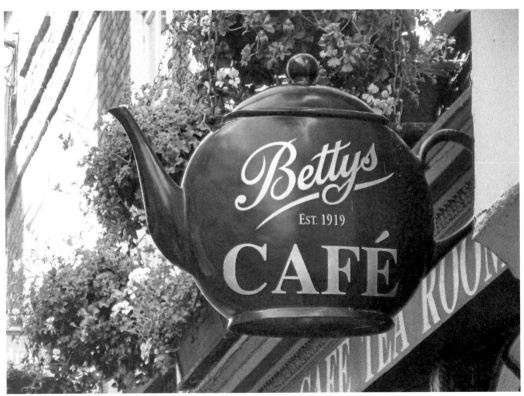

TERRY'S

THE . . . CENTRE OF THE CITY.

RESTAURANT, CAFE, and CONFECTIONERY ESTABLISHMENT.

Telephone No. 28.

ST. HELEN'S SQUARE, YORK.

Telegrams: "Terry, York."

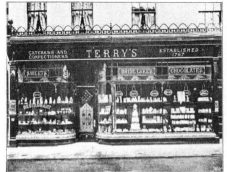

Within 100 yards of :—
The Cathedral
The Guildhall
The Museum
Exhibition Buildings.
Festival Concert Rooms
The City Walls
General Post Office
Market Place
Theatre Royal
N.E. Motor Garage
River Ouse
The Mansion House

Within 10 minutes of :—
The Station
Tram Terminus
Castle and Law Courts
Merchant's Hall
The Cattle Market
Opera House and Empire

Chocolates, Bon Bons,
Boiled Sweets and
Confectionery of every
description.

Specialities:—
Chocolate Nougat
de Montelimart
Walnut Toffee
Boiled Sugars
Peppermint Creams

Luncheons,
Dinners,
Afternoon Teas, etc.

❋

SMOKE ROOM.
LADIES' TEA ROOM.
WINE AND
BEER LICENSE.

❋

BRIDE CAKES,
from 12 6 to 50 guineas.

Birthday and Christening
Cakes.

Large variety of
Fancy Cakes, Pastry
and Biscuits for
Afternoon Tea.

—— ESTABLISHED IN 1767. ——
When George the Third was King.

Joseph Terry & Sons, Limited, York.

Terry's

Apart from their prestigious St Helen's Square restaurant, outside catering was big business for Terry's with functions catering for Bird's Eye in the Assembly Rooms, the Lord Mayor's parties in nearby Mansion House and dinners at the Merchant Taylor's Hall. Queen Elizabeth was entertained twice and the Duke of Kent once at the Mansion House. One early 1960s Assembly Room lunch involved 380 vegetarian meals, including food for ten vegans – all very new then. Hunt balls and army functions for officers and wives from Catterick were frequent and at one Tadcaster Hunt Ball the guests reputedly included Christine Keeler, Mandy Rice Davies and John Profumo. The new picture shows a Yorkshire Tea delivery van owned by Bettys & Taylors of Harrogate delivering, no doubt, across the square.

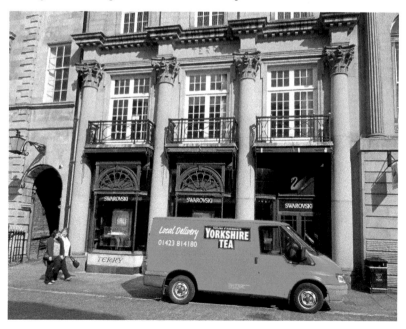

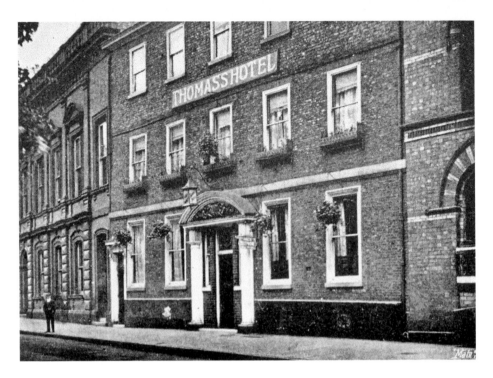

Thomas's Hotel

Thomas's dates back to the 1700s. In 1906 it was at the leading edge of new technology with telephone and electric light – services which in York at the time were very new. The National Telephone Company started ringing in York in 1886 with eleven subscribers paying £50 each while the York Corporation Generating station opened in 1900 in Foss Islands Road.

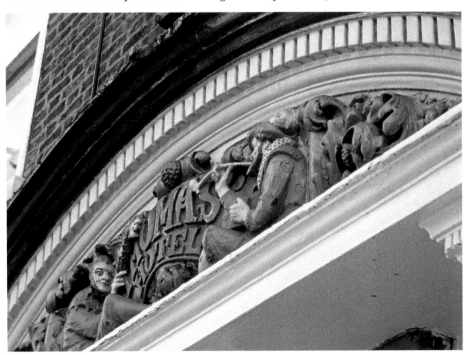

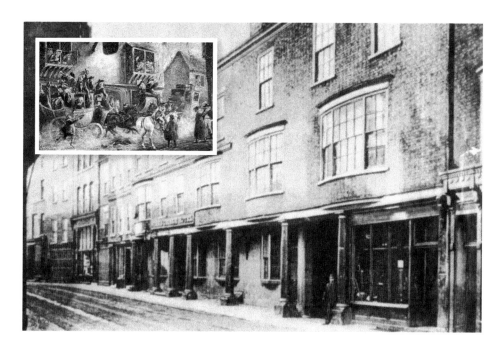

The George Hotel

One of York's coaching inns, serving Hull, Manchester and Newcastle, in Coney Street opposite the Black Swan and the *York Courant* until 1869 when the inn was tragically knocked down to make way for Leak & Thorp. This photograph was taken in 1867 when it was called Winn's George Hotel. There was an earlier inn on the site called the Bull but the landlord, Thomas Kaye, replaced this with the George in 1614. Famous guests included Anne and Charlotte Brontë in May 1849 *en route* to Scarborough; they shopped and visited the Minster. Four days later, Anne died of consumption aged twenty-nine.

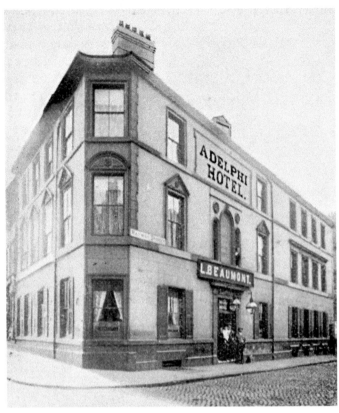

The Adelphi Hotel
Situated on the corner of
Micklegate and Railway
(now George Hudson)
Street. In 1887 it could
boast a new 'well-fitted
bathroom with shower and
spray baths'. The luncheon
of six courses, with wine
for half-a-crown, was very
popular. It was 'under
the regime' of Mr Lewin
Beaumont at this time. It
was once the Railway King
(after Hudson) and is now
the Reflex night club.

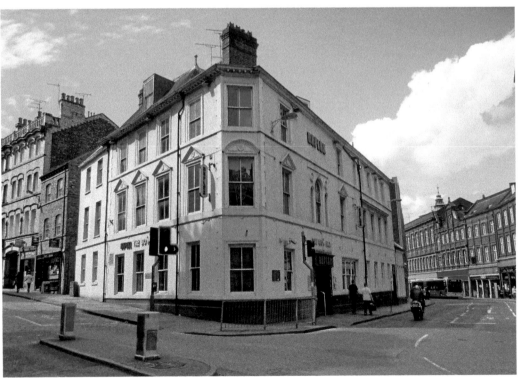

Chapter Six: Tourism

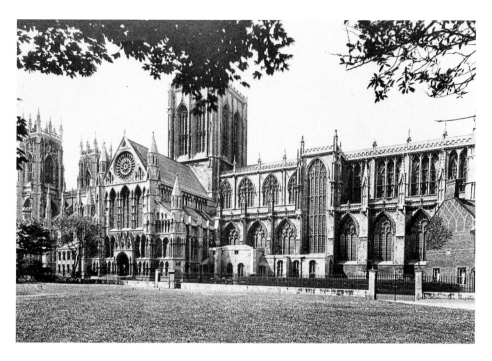

Tourism: York's Chief Industry

The Minster is perhaps the most famous of York's many attractions but it is the other, more discrete tourist activities that make the city what it is today, for example the fascinating, truly frightening ghost walks that take place each night in this most haunted of English cities.

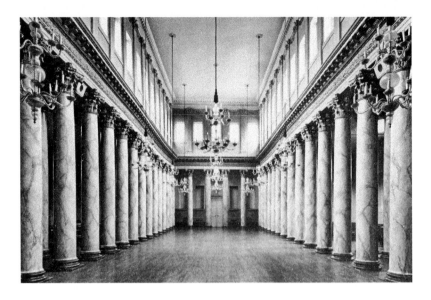

The Assembly Rooms

During the first half of the eighteenth century, York was one of *the* places to be. The Assembly Rooms, completed in 1732, epitomised the high social status of the city: it is one of the earliest neo-classical buildings in Europe, built in the Palladian style. Attracting well-heeled visitors from all over the North, it provided local and visiting gentry with a sumptuous venue for their games of dice and cards, dances and tea parties. John Vanbrugh, architect of nearby Castle Howard, described his 1721 visit to York: 'A Race every day and a Ball every night; with as much well look'd Company as ever I saw got together The Ladies I mean in Chief'. Today the building still exudes style and, as an Italian restaurant, makes for a delightful place to dine in between its forty-eight Corinthian pillars. The photographs show the rooms before and after conversion to the restaurant.

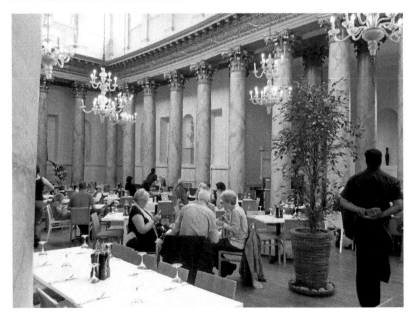

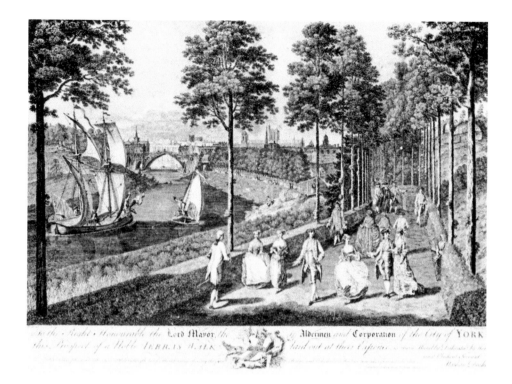

To the Right Honourable the **Lord Mayor**, *the* **Aldermen** *and* **Corporation** *of the City of* YORK *this Prospect of a Noble* **TERRIS WALK** *...*

The New Walk

The place to promenade in the eighteenth century, it was laid down and its trees planted in 1730, but records exist of a walk here from 1547. In 1739 it was extended beyond the Blue Bridge. A succession of bridges spanned the Ouse here, the fourth of which was flanked by two Russian cannon presented to the city after the 1855 Siege of Sebastopol. The new picture shows the newest bridge: Millennium Bridge, which cost £4.2 million and was inspired by the spokes of a bicycle.

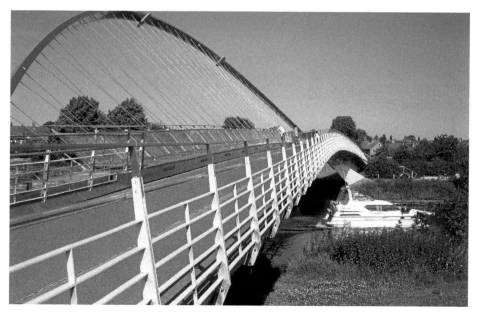

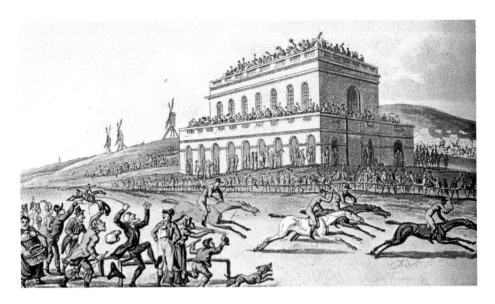

The Knavesmire

The largest and best known of York's strays, Micklegate Stray – or the Knavesmire as it is popularly known – has long been a focus for entertainment, from public executions in the past to horse racing today. Knavesmire hosted hangings from 1379; its most celebrated victim being Dick Turpin hanged that same year. The last hanging was in 1801 – Edward Hughes swung for rape – after which the gallows were moved to a location near the castle. A paved area with a small plaque today marks where the scaffold was, on Tadcaster Road, opposite Pulleyn Drive. It was originally a gibbet post; the gallows replaced the gibbet in 1379 and remained until finally pulled down in 1812. Other gallows existed in Burton Stone Lane and at the Horsefair at the junction of the Haxby and Wigginton Roads. John Carr's fine 1755 grandstand is shown in the old picture.

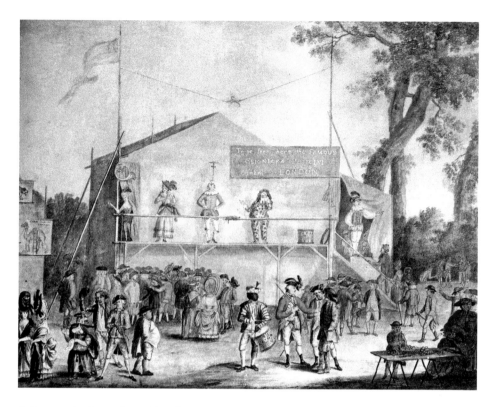

A Day at the Races by ... Blondie ?

Today, of course, the Knavesmire is famous for an altogether less gruesome form of entertainment: York races are amongst the most prestigious in the country. In July 2011 York Racecourse Music Showcase Weekend presented two concerts featuring Blondie and Scouting for Girls. The new picture shows Phil Musgrave enjoying his stag party at the Knavesmire before his marriage to Helen Clayton in July 2011. The old 1769 image is in York City Art Gallery and pictures the 'Famous Seignniora Pupicini from London'. Phil is in Redcar.

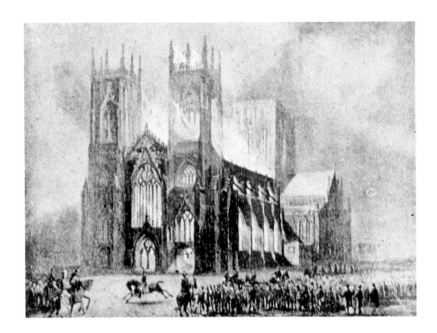

York Minster

The ecclesiastical credentials of York Minster require no introduction, but the Minster is today equally important in a secular sense – as a symbol and focus of York's tourist industry. Over the centuries it brought visitors from all over the world and has laid the foundations for tourism here. The Minster was set on fire in 1829 in an act of arson by Jonathan Martin; in 1840 fire destroyed the Nave roof and vault, as pictured here, and in July 1984 a third fire broke out after the Minster had been struck by lightning. The Minster was on fire again in July 2011 when the York Schools Choral Partnership Concert took place featuring Ralph Butterfield School, Haxby, the Minster School, Lord Deramore's School, Heslington and Westfield School.

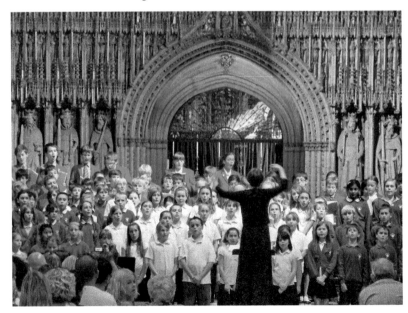

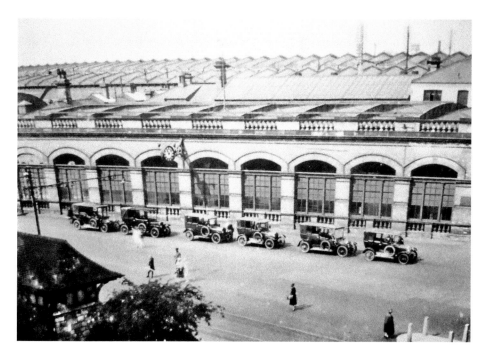

York Businesses and Industries
A selection of York businesses and industries, taking in taxis and buses, cathedral stonemasons and alleyway dairies, insurance giants, utilites, and removal men...

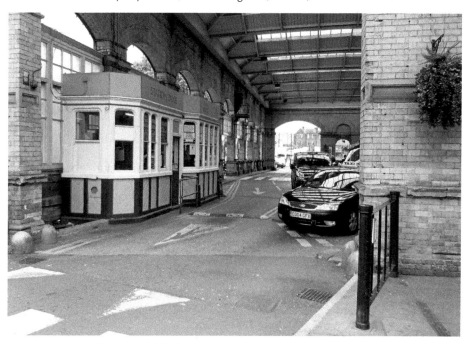

YORK'S
BUS
BUILDERS

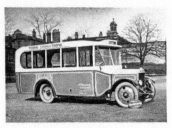

NORTHERN MOTOR UTILITIES LTD.
WALMGATE BAR
Telegrams : " UTILITIES
'phone - York." **YORK** Telephone : 2121 York.

LONDON : BIRMINGHAM : MANCHESTER

FULLY equipped garage with machine tools, acetylene
and electric welding, electrician's shop, blacksmith's shop,
tinsmith's shop, bodybuilding and painting, tyre press, etc.

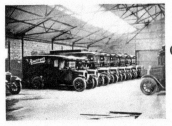

THE
HAULAGE
CONTRACTORS
OF
THE
NORTH

Northern Motor Utilities

This fascinating advertisement appeared
in *York Historical-Pictorial* published in
1928 by Hood & Co. of Middlesbrough.
It promotes this national company's
credentials as coachbuilders and
displays a key client in the shape of an
impressive fleet of Rowntree's delivery
vans. The new photograph shows an ftr
bus – one of the longest buses there is
– incongruously winding through the
narrow medieval streets of York. The
previous page shows York's taxi industry
at York stations old and new.

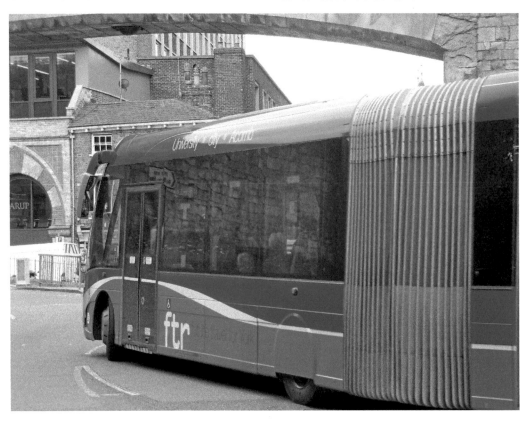

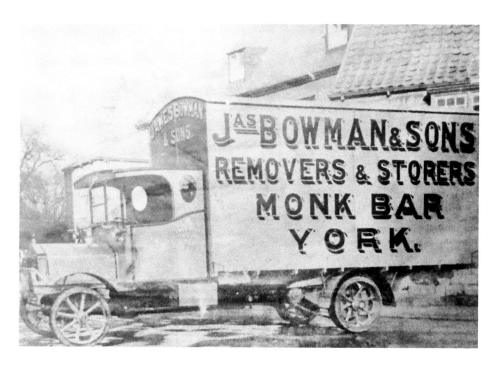

Bowman Removals, Monkgate

This removal firm was set up in the 1840s with 'vans by road, rail or sea'. The company had warehousing on both sides of Monkgate and in St Maurice's Road. It closed in the 1970s having passed through six generations of the Bowman family. The new picture shows that god does not always move 'in a mysterious way His wonders to perform'.

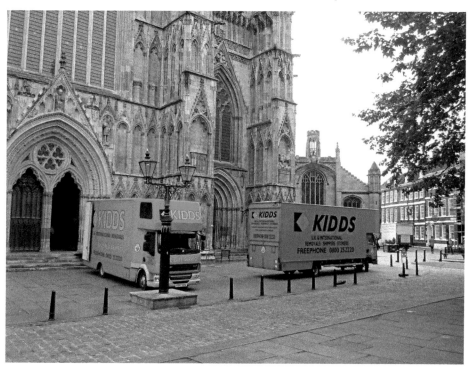

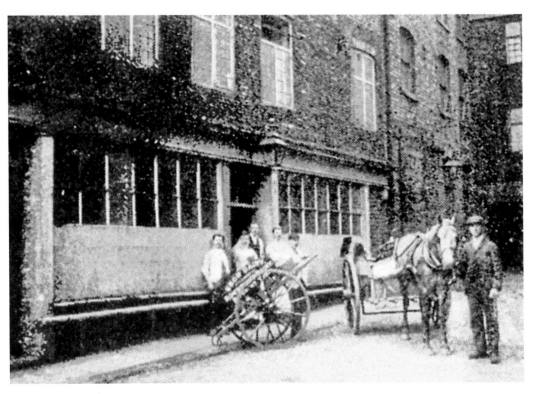

The Ebor Dairy

Founded in Lady Peckitt's Yard in 1866 by Joseph Rowntree it was sold to Mr W. F. Chambers in 1892. Fresh butter was churned daily on the premises and in 1893 they opened the Kiosk on Holgate opposite St Paul's church, followed by a bakery on Pavement in 1896. A lion escaped from a circus in Parliament Street in the early 1900s and was cornered here.

G. W. Milburn, Sculptors

A city with such a wealth of ancient buildings, ecclesiastical and otherwise, would naturally support businesses that repaired and maintained these buildings. Bootham Bar sculptors G. W. Milburn was one such company, proudly displaying their King Edwin Statue in York Minster in this *York Historical-Pictorial* advert. Edwin was the king responsible for establishing the first stone church on the Minster site in 627. Today's masons for the Minster are shown in the new picture.

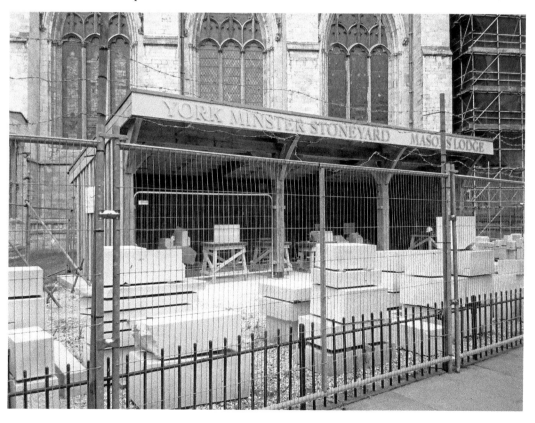

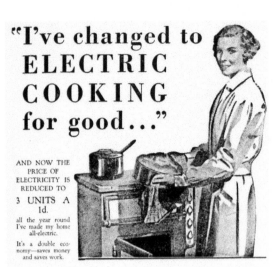

"I've changed to ELECTRIC COOKING for good..."

AND NOW THE PRICE OF ELECTRICITY IS REDUCED TO

3 UNITS A 1d.

all the year round I've made my home all-electric.

It's a double economy—saves money and saves work.

1d. COOKS A 4-COURSE DINNER FOR 6

1d. PROVIDES A 10-GALLON HOT BATH

1d. BOILS A 10-GALLON WASH-BOILER

RENTALS OF APPARATUS ARE ALSO REDUCED — FOR INSTANCE, AN ALL-ELECTRIC KITCHEN WITH DE-LUXE COOKER, WASH-BOILER AND WATER HEATER IS 10/6 A QUARTER, INSTALLED AND MAINTAINED FREE

ENQUIRE AT THE

ELECTRICITY SHOWROOMS CLIFFORD STREET, YORK

Telephone 2168-9

York Corporation Electric Company

The (electric) lights were first switched on in 1899 when York Corporation Electricity Committee's electricity generating station opened on the Foss. By 1929 there were 16,470 consumers. The chimney survives to this day. The 1938 advertisement shows what we take for granted now as a discretionary investment – hiring cookers was very popular. A bewildering array of televisions in an electrical goods store at Clifton Moor makes the new picture.

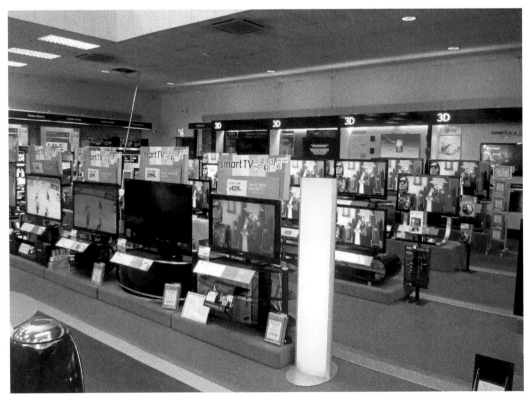

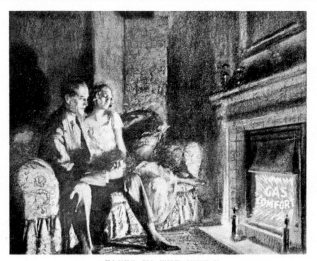

York Gas Company

Gas lighting, or 'the lamp that wouldn't blow
out', was introduced to York by the York
Gas Light Company in 1822 on the banks of
the River Foss near Monk Bridge. The York
Union Gas Light Company was formed in
1836; rivalry was intense with workmen from
the former filling in the latter's excavations;
the two companies amalgamated in 1843 to
form the York United Gas Light Company.
In 1824 there were 250 consumers; this had
risen to 34,000 by 1963. In 1912, coverage
was extended to seven miles from the Ouse
Bridge to take in Haxby, Wigginton and
Strensall. The 1928 advertisement on the
right could not be said to boast the last word
in snappy copy although, in mitigation, it
was aimed at architects and builders – poor
woman.

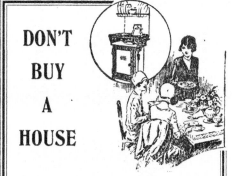

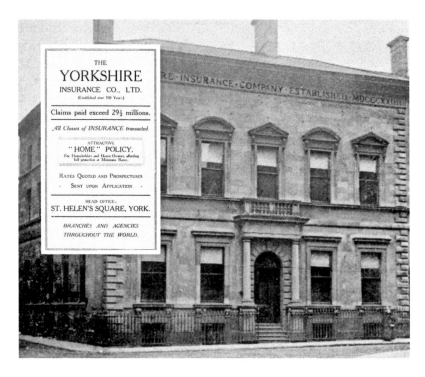

York Fire and Life Insurance Company

Established in 1824 in the same building pictured here in St Helen's Square; its income in 1897 amounted to £223,111 with funds of just over £1 million. It was acquired by General Accident in 1967 and, via Commercial Union and Norwich Union, eventually became part of Aviva in 2009. Today the building is Harker's Bar, named after the hotel that stood opposite Terry's here before its 1929 demolition and move to Dringhouses. The newer photograph shows the face of the insurance industry today in York - Aviva's building in Rougier Street.